Richard Shone

TOULOUSE-LAUTREC

With 40 colour plates

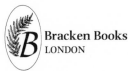

Bracken Books
LONDON

Originally published by Thames and Hudson Ltd, London

This edition published 1984 by Bracken Books,
a division of Bestseller Publications Ltd,
Brent House, 24 Friern Park, North Finchley, London N12,
under licence from the proprietor

This book was designed and produced by
John Calmann and Cooper Ltd, London

ISBN 0–946495–19–X

Printed in Hong Kong by Mandarin Offset Ltd

Introduction

TOULOUSE-LAUTREC'S FAME AS A MAN, the Hollywood 'character' of 'Moulin Rouge' drinking himself into lunacy amidst frenetic cancan dancers, has tended to obscure his particular achievements in painting and lithography. In an era of exceptional brilliance and diversity in French art, assessments of his position as a painter have frequently been evaded in favour of the legend of 'the isolated genius', pursuing the only subjects available to a grotesque dwarf in revolt against an aristocratic background. Yet even the most cursory knowledge of the art of his time reveals Lautrec as essentially conservative in his style and choice of subject, indebted not only to such older painters as Manet, Degas and Renoir, but to the broader intellectual and literary climate of France from Baudelaire to Maupassant and the Goncourt brothers.

It is hardly surprising that someone who was primarily a recorder, a man who enjoyed mimicry and disguise and who possessed an extraordinarily swift eye, was heavily influenced by what he saw around him in the work of others. Although Lautrec's contribution to the art of his time was quite distinct – and in lithography he was an inventive master – to view him in isolation is to deny his instinctive gift for synthesis and his place in an age which he reflected with such accuracy and compassion. Too often regarded as a cynical and dispassionate follower of Degas, Lautrec was also capable of tender melancholy and a gently humorous appreciation of the human scene. Few of his works reach the extravagant pitch of his sketch of Yvette Guilbert (*plate 24*). It is Lautrec's embracing humanity in the depiction of contemporary men and women which gives him a place alongside Van Gogh in the Post-Impressionist school.

Henri-Marie-Raymond de Toulouse-Lautrec-Monfa was born into one of France's oldest families at its house in Albi on 24th November 1864. His father, the Count Alphonse, was a sportsman, artist and eccentric; milking his mare in the Bois de Boulogne is one of the more well known examples of his odd behaviour. Although Lautrec's relations with his father were sometimes strained and Lautrec guyed him mercilessly in several drawings and lithographs, father and son were never estranged as is popularly supposed; they had in fact considerable affection for each other. Lautrec was more deeply attached to his mother, who took care of his education, nursed him on several occasions and was the centre of a large family of relations. Lautrec retained a strong family feeling: one of his closest, lifelong friends was his cousin Gabriel Tapié de Céleyran (*plate 40*).

Against the benefits of this privileged background with its wealth and estates – and he was always to be financially secure – must be placed Lautrec's poor health, for he was subject to a bone disease which obstructed his natural development. In 1878 and 1879 he suffered minor fractures, first on the left leg and then on the right; neither healed properly or continued to grow. Thereafter he walked with difficulty (though he swam well) and never grew in height beyond four foot six inches. Above short legs and a normal torso was a generally unattractive face enlivened by charming, quick eyes behind a pince-nez and lips of 'startling scarlet'. It must be stressed at once that Lautrec's natural disposition was mercurial and kindly; he had many devoted friends, some of whom have left testimony to his affectionate and winning manner.

One of these friends was Thadée Natanson, one of three brothers who were joint editors of the famous periodical, the *Revue Blanche*, to which Lautrec contributed lithographs and drawings in the mid-nineties. Natanson wrote some delightful and vivid memoirs of the painter. In one passage (*Peints à leur tour*, Paris, 1948) he describes Lautrec's arrival at the offices of the *Revue Blanche*:

To reach the editorial offices in the rue Lafitte Lautrec was obliged to hobbledy-hobble across the whole width of the courtyard, which was overlooked by four great facades. He was never by himself. . . . more often than not he was accompanied by his cousin Tapié de Céleyran. It was never his companion we used to watch, constrained to dawdle until Lautrec caught up with him, but Lautrec himself, even when we could only see the promising rocky motion of his tiny person, with an end of muffler escaping from round his neck, and the bowler hat he sometimes waved. Lautrec! Lautrec struggling to wrench one shoe after the other from the paving, then stopping, less to expostulate or loudly hail someone as simply to stop. Not once did he admit it was to get his breath! Then he was off again, more hindered than helped by his little bit of stick.

Natanson goes on to describe how, on Lautrec's arrival, a flow of bubbling conversation issued from the 'tiny person' perched on a sofa, his legs hardly touching the floor. He would often recount his adventures, showing an extraordinarily retentive memory for the look of people and places, whether it was an operation he had attended in a hospital or an evening spent in Renoir's studio. The promise of future events inspired his imagination too – such as the idea of dropping everything and going to London for Queen Victoria's funeral if 'La Queen consented to die'.

Although always conscious of his deformity, the bitterness of some of his remembered remarks is not typical. Yvette Guilbert, complaining of how ugly she appeared in Lautrec's studies of her, told him he was a genius at distorting. 'But naturally,' he replied sharply but, one may be sure, not without a touch of humour. On another occasion it has been recorded that he said his ambition 'was to find a woman uglier than himself in order to breed a monster'. The satiric bite of some of his mature work, so often supposed to be the inevitable result of a cripple's misanthropy, is in fact discernible in many drawings made before his accidents.

After that time, the sporting pursuits traditional to his class, and his family in particular, were denied him. But drawing was also very much a family tradition and, according to Lautrec's grandmother, shooting a bird provided a threefold pleasure for her sons – 'shooting, eating and drawing it.' Sketching a horse or a duck was simply a further manifestation of a robust appetite for life; art as a profession was inconceivable. But although Lautrec's family was puzzled, he encountered little opposition to his desire to study painting seriously. In 1880 he began to draw and paint with more application under the instruction of a sporting artist, René Princeteau, a deaf-mute friend of Count Alphonse. Then in March 1882 Lautrec arrived in Paris and was soon working under Léon Bonnat, a well-known Salon painter. From the portraits undertaken that summer at Céleyran (*plate 2*), we can see a lively progress in Lautrec's handling of paint, a more incisive line than he had achieved hitherto and an admiration for the later, open-air work of Manet.

In the following year, having progressed to the Atelier Cormon, he continued to improve under a routine of hard work and developed an independent and enthusiastic liking for the older Impressionists. For some time we find frequent reminiscences of Manet, Pissarro and Renoir (e.g. *Emile Bernard* (*plate 4*) and in such a work as the *Portrait of the Artist's Mother* (*plate*

3)), remarkable for a boy of nineteen, he seems to have looked at the speckled domestic interiors of Berthe Morisot. But Lautrec's interest in the Impressionists' discoveries in the field of light was not profound; indeed one of the limitations of his later work is an ambiguous definition of light, even when his subject was found out of doors as in *Mlle Dieuhl au Jardin, La Songeuse* or *M. Henri Dihau* (*plates 9, 10 and 11*). In his large interiors such as the *Ball at the Moulin de la Galette* (*plate 7*) he relies more on linear compositional devices for defining space than on varieties of tone as employed by Renoir in his great picture of the same dance-hall.

Lautrec exchanged Renoir's painterly hedonism, whose luminosity carries an almost normal message, for a visual record which, although touched here with melancholy, is essentially detached. With such a temperament, it was inevitable that he should fall under the spell of Degas, not only from a certain similarity of artistic and social attitude, but also because Degas was a master of subjects which Lautrec continued to explore. Degas was 'the artist whom he loved best', according to his fellow student François Gauzi; similar testimony appears in the English painter William Rothenstein's memoirs. Degas was the great precursor as far as modern subject matter is concerned, although such artists as Constantin Guys and Jean-Louis Forain must also be accounted for in Lautrec's development. Lautrec was one among many who, in the 1880s and 1890s, quarried the concert halls, dance studios, theatres and cafés for his art. Besides Manet and Degas, there was a host of lesser painters with the same fascination, led by Sickert, who was then well known in Paris and a particular friend of Degas. Nor should we forget the work of Seurat, who may have been influenced in his *Le Cirque* by Lautrec's own major early work, the *Cirque Fernando* (*plate 6*). No two artists could be more different in their approach, methods and expression; their sharing of common subject matter from a particular sphere of Parisian life only underlines Lautrec's participation in the artistic concerns of his age. In their turn, younger artists found inspiration in his adopted motifs – early Kees van Dongen and Maurice Vlaminck, for example, and more especially Picasso in his first Paris period.

Like many of his contemporaries, Lautrec was deeply interested in Japanese art, several of the most characteristic features of his work finding their origin in Japanese prints – direct (for Lautrec bought many of them) or through the example of Degas. His need for a swift delineation of space in order to focus on the figurative element led him to adopt certain Japanese solutions – a decorative application of outline and silhouette, broad areas of unmodulated colour, sharp diagonals and receding planes, a tilted viewpoint and the cutting of figures at the canvas edge to suggest depth and continuity. Several of Lautrec's major compositions rely on such devices to connect the foreground centres of interest, often including detailed 'portraits' with hastily sketched and ambiguous backgrounds. The *Cirque Fernando* exhibits many of these characteristics, particularly the great dissecting curve of the edge of the ring, itself absolutely unmodelled, and the abbreviated, humorous silhouette of the clown at the left. In *Jane Avril Dancing* (*plate 16*) the horizontal lines framing the two distant spectators echo the waistline and upraised leg of the dancer, functioning simultaneously as spatial definition and surface pattern. Lautrec's debt to Japanese prints through Degas' work is clearly seen in *La Toilette* (*plate 8*), in which he attempts a more ambitious spatial scheme through a compelling interchange of curves and diagonals, though once again the figure is not entirely successful in its relation to the chairs and tub beyond. And unlike Degas, any suggestion of lighting is here reduced to a minimum. It is an essentially linear work and from that point of view provides

a memorable image. In its seriousness of mood and the absence of any exaggerated feature, it is unusual among Lautrec's finer paintings.

In 1885 Lautrec ostensibly left Cormon's studio though he returned regularly to see friends, among whom, besides French students, was Van Gogh, whom he met in 1886 and of whom he made a vivid drawing in the following year (*plate 5*). Lautrec's large circle of friends included the English painter Charles Conder, who appears in several sketches and lithographs, an English artist Warrener (*plate 20*), the very young William Rothenstein, and Oscar Wilde, of whom Lautrec made a celebrated portrait and was to include in the crowd watching La Goulue (*plate 30*). Lautrec constantly portrayed his friends in his work – the painter Joseph Albert gazes impassively at the dancing couples of the Moulin de la Galette (*plate 7*); the amiable champagne salesman Maurice Guibert gives an uncharacteristic stare of cynical defeat in *À la Mie* (*plate 12*) and appears more typically among companions in the *Quadrille at the Moulin Rouge*. Such portraits add an extra dimension to Lautrec's passion for recording life as he found it.

He was seldom alone in these nightly excursions to the cabarets and halls of Montmartre and nothing is further from the truth than the popular image of him shuffling to a table for a long, unaccompanied evening of drawing and drink. Although the paintings which resulted from these visits can appear decidedly impartial – the coolest of records – Lautrec was in fact on the closest terms with some of the performers. And how fortunate he was in the intoxicating variety of singers and dancers to be found all at the height of their powers and all within a small area of the city.

Montmartre had a long tradition of dance-halls and café-concerts. Forain and Guys were among the first artists to be inspired by them; Renoir painted the Moulin de la Galette in 1876, when it was a popular, unsophisticated hall still somewhat countrified (Van Gogh's picture of its exterior of 1887 stresses this) and as yet undiscovered by the fashionable public, who already frequented the Folies-Bergère and who can be seen in Manet's famous picture of its bar of 1881. At the same period, Degas was depicting the singers at Les Ambassadeurs with its coloured lights and open-air stage and the diseuses – female singers and entertainers – launching into traditional songs or boulevard ditties. The first of these places to inspire Lautrec was Le Mirliton (which remained a favourite), a cabaret opened by the burly Aristide Bruant who also sang his low-life Parisian songs at Les Ambassadeurs. Bruant was well known for the stream of often obscene abuse with which he greeted the clientele of Le Mirliton. Between 1888 and 1889 Lautrec was principally inspired by the Moulin de la Galette but in October of the latter year the Moulin Rouge was opened in the Boulevard de Clichy; for some years its stars, dancers and strolling clientele provided subjects for many paintings, and for his most famous work, the poster for La Goulue (1891), which brought him considerable recognition. La Goulue (the Glutton), plump, blond and famed for her high-kicking execution of the quadrille, was frequently partnered in that dance by the sinister and seemingly boneless Valentin-le-Désossé, who during the day managed a modest café, but at night was the agile and familiar figure we know from Lautrec's posters and paintings (*plates 14 and 29*).

In contrast to the bawdy physical presence of La Goulue, whose self-important swagger Lautrec catches in his portrait (*plate 15*), Jane Avril (1868-1943), a star of the Moulin Rouge from its opening and later at numerous cabarets, was a sensitive and intelligent girl with a natural grace and refined manners – in fact something of a phenomenon among the robust company of the places in which she worked. Occasionally Lautrec shows her talking to aquaintances – more often she is alone, dancing in her self-absorbed yet

passionately personal style (*plate 16*) or, as in *Jane Avril at the entrance of the Moulin Rouge* (*plate 17*) and its companion *Jane Avril leaving the Moulin Rouge* (Wadsworth Atheneum, Hartford, Connecticut), she is caught in a moment of melancholy reflection. Jane Avril's greatest years as a performer coincided with the period in which Lautrec was her friend and recorder. She performed in London in 1897, and in New York in 1901. She later married and died in 1943.

Of the other performers who attracted Lautrec – and some of them were not a little indebted to him for their celebrity through his posters and lithographs – Yvette Guilbert was by far the greatest, a singer of international repute whose career continued into the 1930s. Her distinctive, intelligent face, unadorned dress and long black gloves inspired Lautrec to some of his most blatantly wicked caricatures. The biting economy of his line as he delineates her sharply illuminated face and angular shoulders brings to mind his great admiration for Goya's lithographs, the *Disasters of War.* Lautrec's roving eye was not, however, confined to cabarets and individual singers; the theatre was equally stimulating, with its artificial lighting, unusual costumes, exaggerated make-up and the unfamiliar viewpoints it afforded. Drawings and lithographs include the great actors and actresses of the day: Sarah Bernhardt in *Phèdre*, Guitry, Coquelin and Réjane. Marcelle Lender (*plates 27 and 28*) was drawn by Lautrec in 1893 but it was two years later, when she was appearing in *Chilpéric* at the Theâtre des Variétés, that Lautrec became entranced and would go night after night to study the twisting elegance of her back as she danced the bolero.

Lautrec's great picture, the *Salon in the rue des Moulins* (*plate 23*), which contains so much that is characteristic of his best work, was the culmination of a series of studies undertaken in the celebrated and well-appointed brothel where he lived for a period in 1894. Brothel scenes – inmates and clients and the daily routine – feature in Lautrec's work from 1892. He may well have seen Degas' candid group of monotypes of similar scenes carried out in the late 1870s and later used as illustrations to an edition of Maupassant's story *La Maison Tellier.* But where Degas is misogynistic, the younger artist is truthful to what he sees, shirking nothing in his passion for accuracy. A scrupulous objectivity prevents any hint of the pornographic or the voyeuristic; in fact, his pictures of lesbian couples are unusually painterly and of most tender psychological insight. Other artists treating the same theme tend to be rhetorical (as in Courbet) or cloying (as in Pascin); Lautrec gains immensely by his temperate approach. In this he was a pioneer, and such painters as Rouault and Picasso, shortly afterwards, must have drawn inspiration from the unreserved nature of pictures such as the *Rue des Moulins* (*The Medical Inspection*) (*plate 22*).

Lautrec's sensibility was essentially linear, and although his application of paint could on occasion be beautiful, it has little expressive contribution to make in the sense in which we think of the handling of a Renoir or, rather differently, a Van Gogh. Only in his last two or three years do we see emerging a stronger feeling for paint itself, but the pictures are not among Lautrec's successes. Generally, Lautrec used very thinned paint to ensure clarity of line, and for support he preferred unprimed board to canvas. The muted buffs and pale browns of cardboard not only gave a certain depth to the sketches painted on them but were an ideal basis for the often acid colours which Lautrec favoured. Lautrec's near contemporaries, Edouard Vuillard and Pierre Bonnard, also often used board, finding its absorbent properties particularly suited to their gentler aims. Lautrec's preference for flat design, outline and suggestive gesture, his sympathetic nod towards publicity

(although he was startled by his increasing fame, he enjoyed it) and commercial contacts – all these factors contribute to his originality and renown in designing lithographic posters. He made over thirty between the initial one for the Moulin Rouge (*plate 14*) and his death ten years later. Generally they advertise places of entertainment or particular stars such as Jane Avril at the Jardin de Paris, the Irish singer May Belfort with her inevitable little black cat at the Petit Casino, and Aristide Bruant at Les Ambassadeurs (*plate 19*).

As a designer of posters, Lautrec was working in an era of formidable rivalry, for they were already becoming collectors' items. But the success of his often startling images with their bright colours and simple lettering was immediate and even put Jules Chéret in the shade, hitherto Paris's best-known poster artist, from whom Lautrec learnt much. The technical inventions Lautrec made, however, were personal; imitations appeared superficial and inept though he did have some influence on design in England. The best of his posters can be seen as his greatest claim to originality within the European context and they have remained popular and evocative images.

Anyone visiting the Toulouse-Lautrec museum at Albi will realize that Lautrec's output was enormous. There are hundreds of lithographs, drawings and preparatory studies for larger paintings. Long working hours were followed by nights of incessant drinking and a personal carelessness over his health – in spite of kindly watch-dogs sent by his solicitous mother. Debilitating alcoholism resulted in short attacks of insanity and after a breakdown in 1899 he was sent to an asylum at Neuilly, near Paris, for several months' convalescence. He produced there, as proof to the doctors of his recovery, a group of drawings of circus scenes, more remarkable for the fact that they were done from memory than for any intrinsic worth. After his release in May he painted a little at Le Havre (*plate 37*) before going by boat to Bordeaux, where he rented a studio the following year. Most of 1900 was spent in Paris and though he achieved a notable success with *Au 'Rat Mort'* (*plate 36*) his work was generally subdued and clumsy during the rest of this short, last period (*plate 40*) though he made some tentative advances in a more delicate handling of light, as in the *Modiste* (Albi). But his alcoholism had not been cured at Neuilly and by the summer of 1901 he was ill once more. In August he suffered a paralytic stroke and died on 9th September, aged thirty-six, in the home of his mother at Malromé.

1. *Self Portrait in a Mirror*

1880. Oil. 15⅞ × 12¾in (40·3 × 32·4cm)

At the time of this youthful self portrait, Lautrec was still convalescent after his accident of the previous year. Painting and drawing were his chief occupations – mainly sporting pictures, the subjects viewed from a carriage or the windows of his room. The muted colour and thick paint show the influence of Lautrec's master René Princeteau. For a later self portrait – albeit very different – see *plate 30*.

Albi, Musée Toulouse-Lautrec

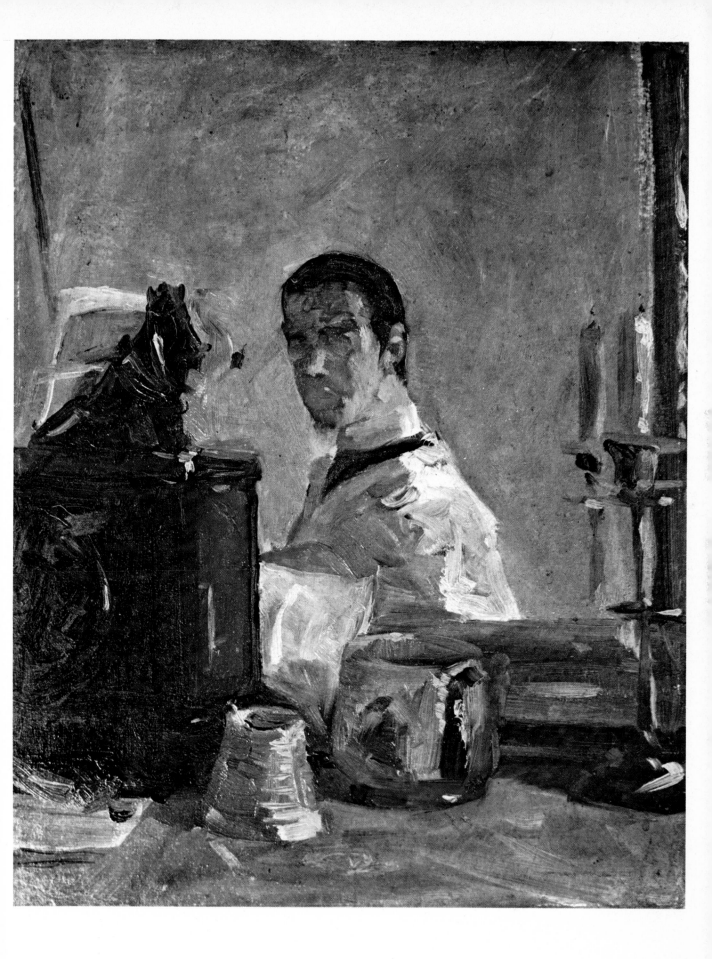

2. *Young Routy at Céleyran*

1882. Oil. 23⅝ × 19⅜in (60 × 49cm)

Painted in the summer at his family home, this study of a
farm hand clearly shows Lautrec's growing
accomplishment in handling oil paint and the first
influence of Impressionism, which he had come to know
in Paris, particularly the work of Manet and Renoir. This
can be seen in the surer sense of tone and more subtle
definition of light – qualities not much in evidence in his
previous paintings of horses and sportsmen where a sense
of movement and vitality were his foremost concerns.

Albi, Musée Toulouse-Lautrec

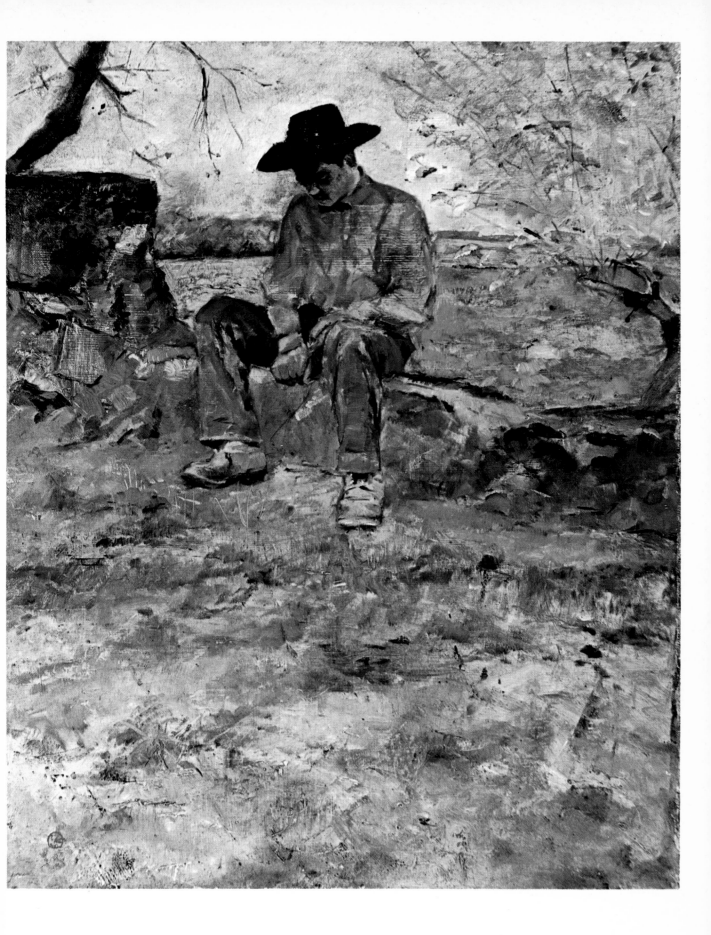

3. Portrait of the Artist's Mother at Breakfast, Malromé

1883. Oil. 36⅞ × 32in (93·5 × 81cm)

An Impressionist technique is here more subtly and delicately employed while Lautrec's intrinsic character as an artist comes to the fore in the thinned paint, sharp accents and linear emphasis of a portrait that is sensitive and deeply felt.

Albi, Musée Toulouse-Lautrec

4. *Portrait of Emile Bernard*

1885. Oil. 21¼ × 17¾in (54 × 45cm)

The French painter Emile Bernard (1868–1941), a rebellious student at Cormon's studio, met Lautrec there in 1885, the year of this beautifully executed portrait with its echoes of Renoir and Degas.

London, Tate Gallery

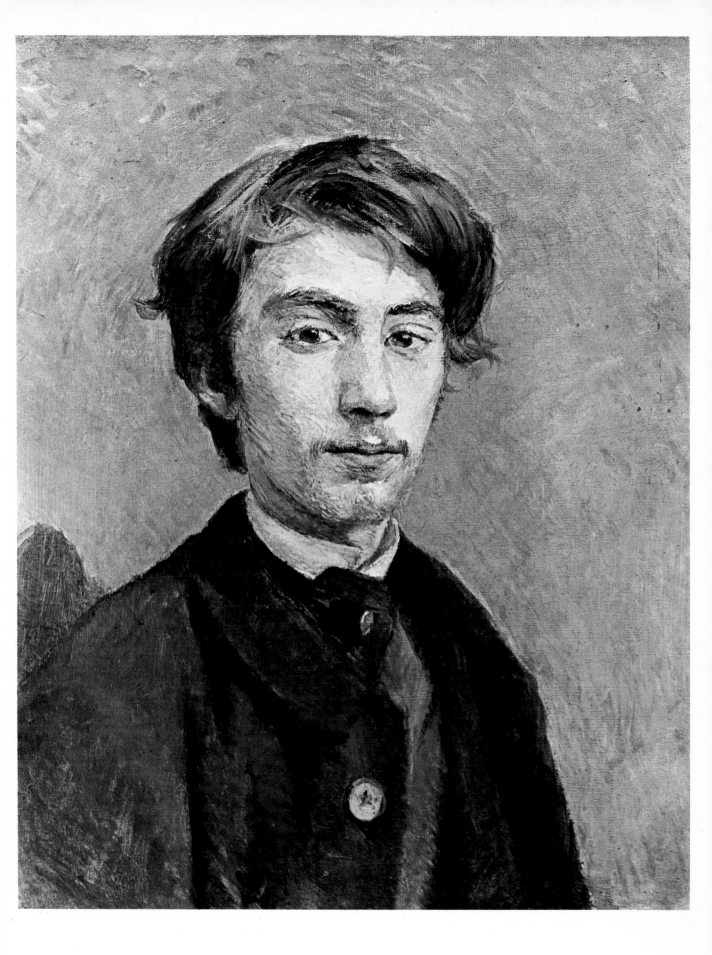

5. *Vincent Van Gogh*

1887. Pastel. $21\frac{1}{4} \times 17\frac{3}{4}$in ($54 \times 45$cm)

Van Gogh and Lautrec became friends when they met at Cormon's studio in 1886 while Van Gogh was a student there; the two painters saw much of each other in Paris until 1888 when Vincent left for the South of France. Van Gogh certainly influenced Lautrec's work at this period and exercised a personal fascination on him which led Lautrec to challenge a denigrator of his stormy friend to a duel.

Amsterdam, National Museum of Vincent van Gogh

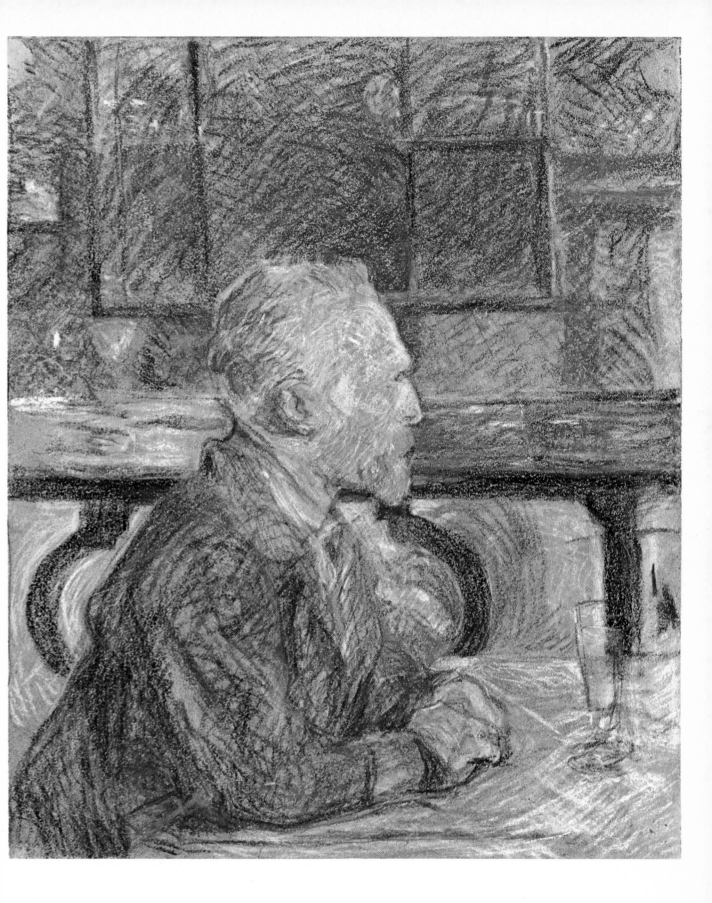

6. *Cirque Fernando: The Ringmaster*

1888. Oil. 39⅜ × 63⅜in (100 × 161cm)

This is the masterpiece of Lautrec's earlier work, the one in which he first fully explored the characteristics of his later painting, among them the strong linear application of paint, minimal spatial definition, silhouette and caricature. The picture hung in the foyer of the Moulin Rouge from 1889.

Chicago, Art Institute

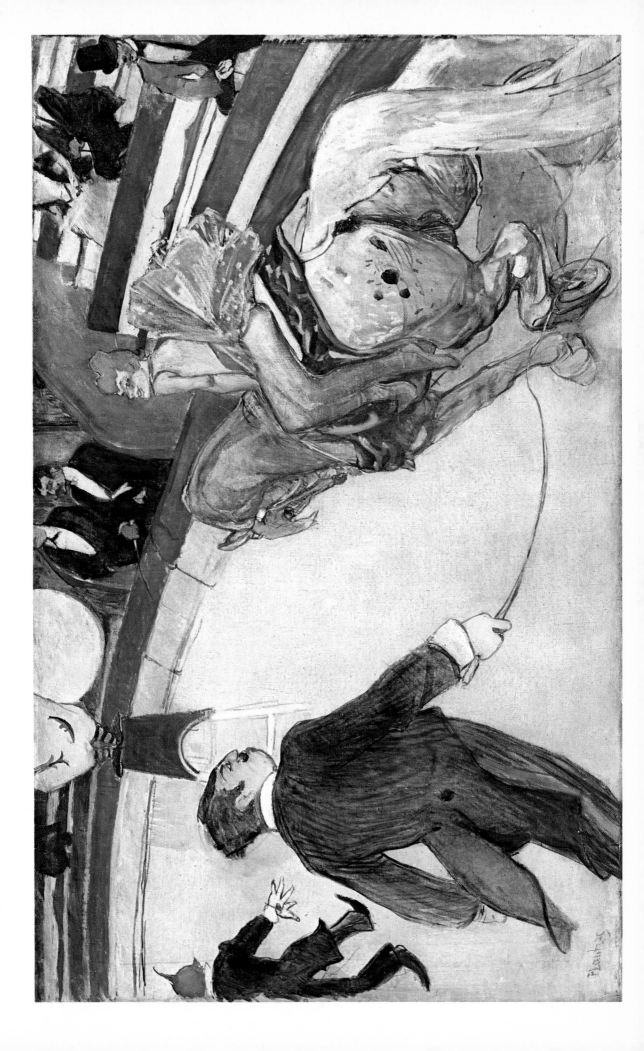

7. *The Ball at the Moulin de la Galette*

1889. Oil. 35 × 39⅞in (88·9 × 101·3cm)

Lautrec's portrayal of dancing couples watched by single, well-characterized figures makes the comparison between this painting and Renoir's joyous depiction of the same dance hall unavoidable (1876, Louvre). Where Renoir is sensuous and idealistic, Lautrec's image is clear-eyed and sombre with its dull vermilions and acid greens.

Chicago, Art Institute

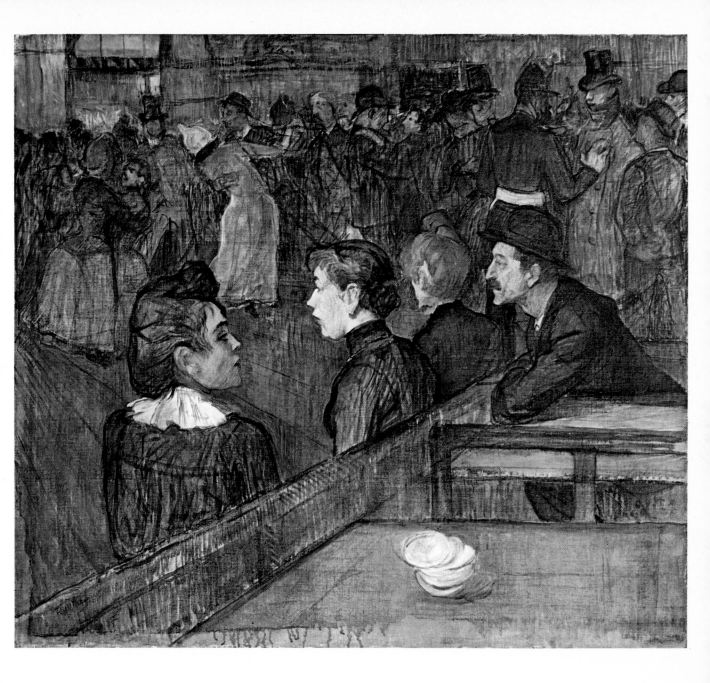

8. *La Toilette*

1889–90. Oil. $20\frac{7}{8} \times 15\frac{5}{8}$in (52 × 40cm)

Although the handling of paint is fully expressive of
Lautrec's linear sensibility, the composition of this picture
owes much to Lautrec's profound admiration for Degas.
This is particularly evident in the isolated, somewhat
ungainly posture of the woman, the inclined floor and
high viewpoint which allows the furniture to be abruptly
cut at the picture edge as in Japanese prints. Frequently
ascribed to 1896, it is however more in keeping with
Lautrec's stylistic development of about 1890 and is clearly
referred to in a letter of the painter's to a Parisian art-
dealer in August 1890, shortly after its return from an
exhibition in Brussels.

Paris, Louvre

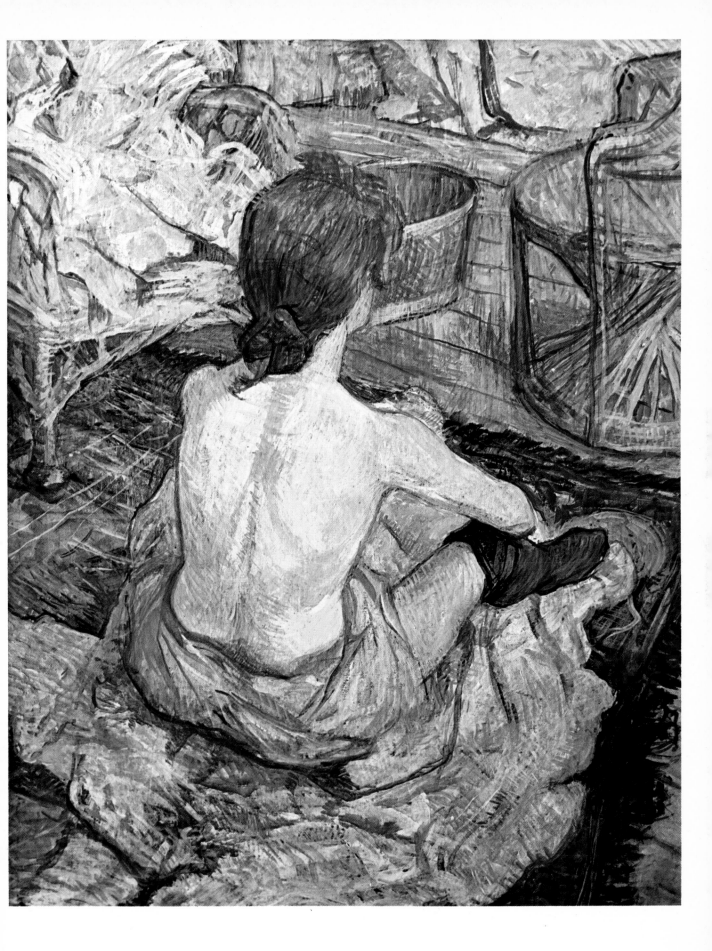

9. *Mlle Dieuhl au Jardin*

1890. Oil. $29\frac{1}{8} \times 22\frac{3}{4}$in (74 × 58cm)

Lautrec painted this portrait of a model, Justine Dieuhl, in the overgrown garden of a Montmartre figure, Père Forest. By this date, Lautrec's repudiation of Impressionist technique was complete and the open air setting, reminiscent of Manet, is now less prominent than the acute characterization of a pert model proudly sporting her elaborate hat.

Paris, Louvre

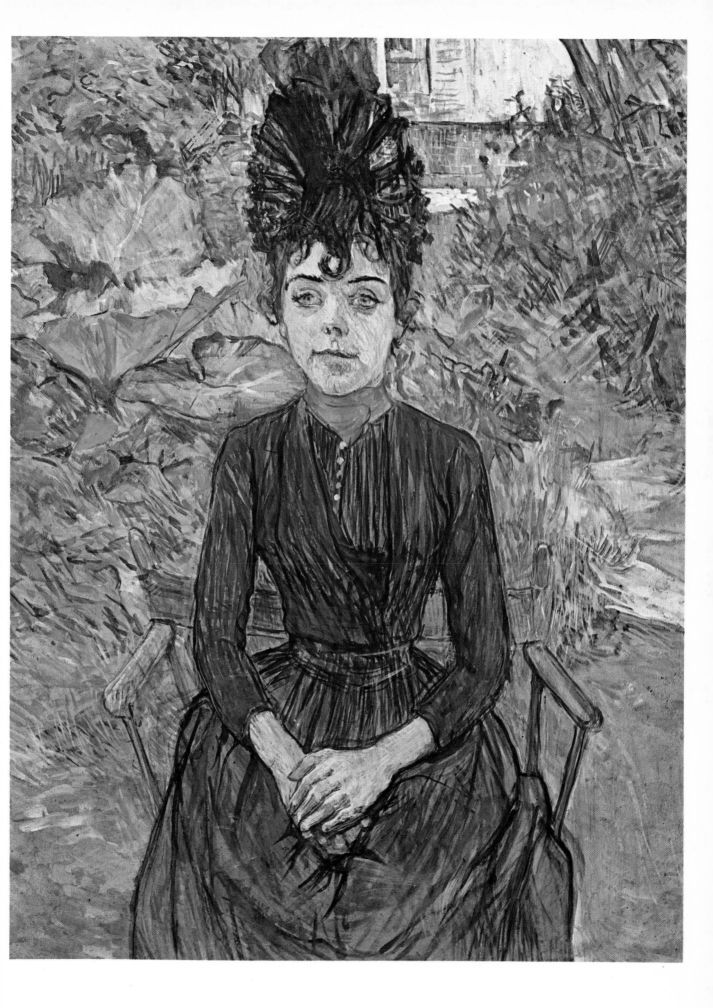

10. *La Songeuse*

c.1890. Oil. $19\frac{1}{4} \times 12\frac{1}{4}$in ($49 \times 31$cm)

A further out-of-doors study of a model Lautrec painted several times at this period called Rosa. *La Songeuse* can be translated as the 'day-dreamer', indicative of the girl's pensive attitude and the picture's subdued and gentle tonality.

Birmingham, Barber Institute

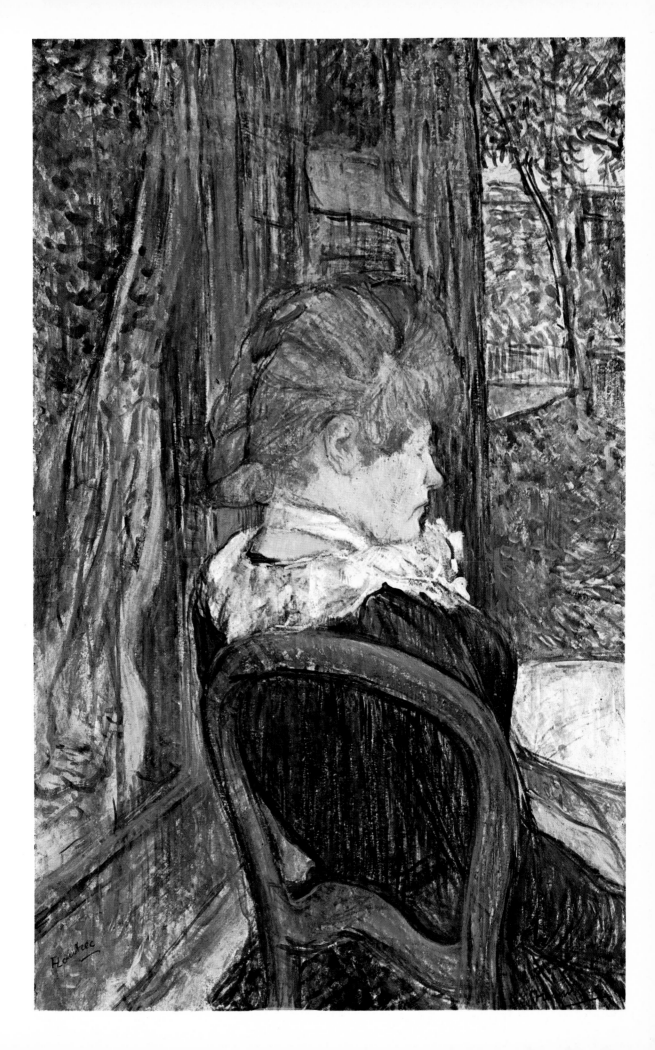

11. *M. Henri Dihau*

1891. Oil. $16\frac{1}{2} \times 11\frac{7}{8}$in (41·8 × 30·1cm)

Like *Mlle Dieuhl au Jardin* (*plate 9*), this was painted in Père Forest's garden. Henri Dihau, his brother Desiré and sister Marie were cousins of Lautrec and friends of Degas. They were a musical family and Lautrec frequently visited them, painting all three cousins, notably Marie playing the piano. Lautrec constantly painted his friends, either including them in large figurative compositions, for example Joseph Albert in the foreground of *The Ball at the Moulin de la Galette* (*plate 7*), or treating them individually as in this humorous, informal study.

Albi, Musée Toulouse-Lautrec

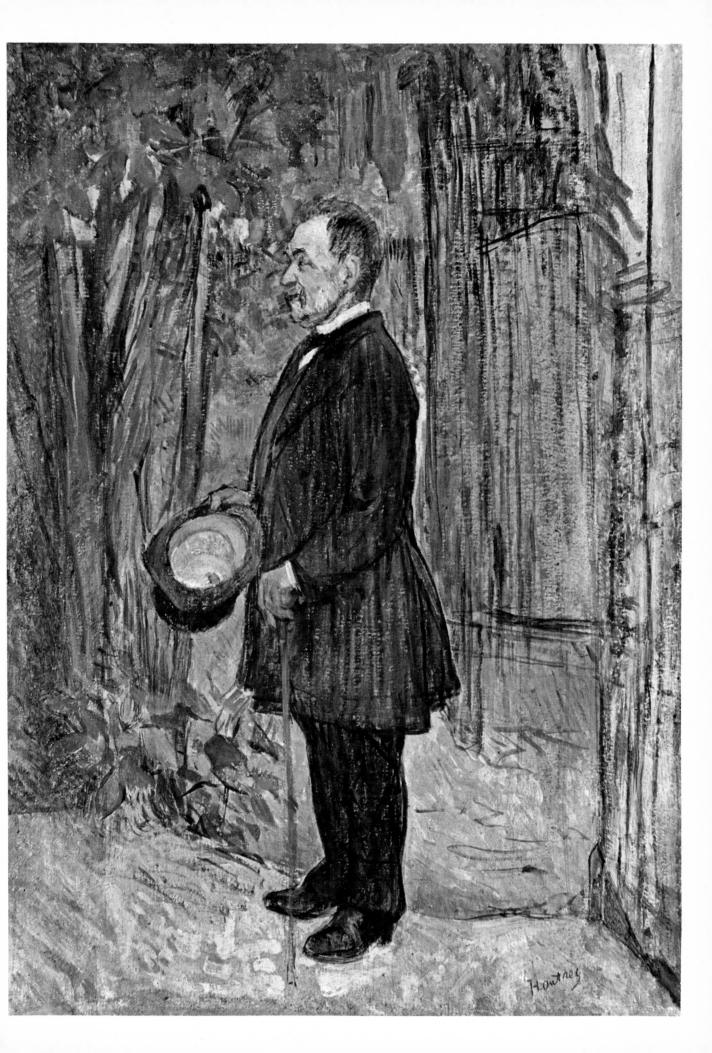

12. *A la Mie*

1891. Oil. 19$\frac{5}{8}$ × 27$\frac{1}{2}$in (50 × 70cm)

This is one of the few paintings by Lautrec in which he posed friends (Maurice Guibert and a Montmartre model) to illustrate a particular theme – of weary dissoluteness and degradation. Perhaps inspired by Degas' *L'Absinthe* (Louvre), the colours are suggestively sour and his line acerbic.

Boston, Museum of Fine Arts

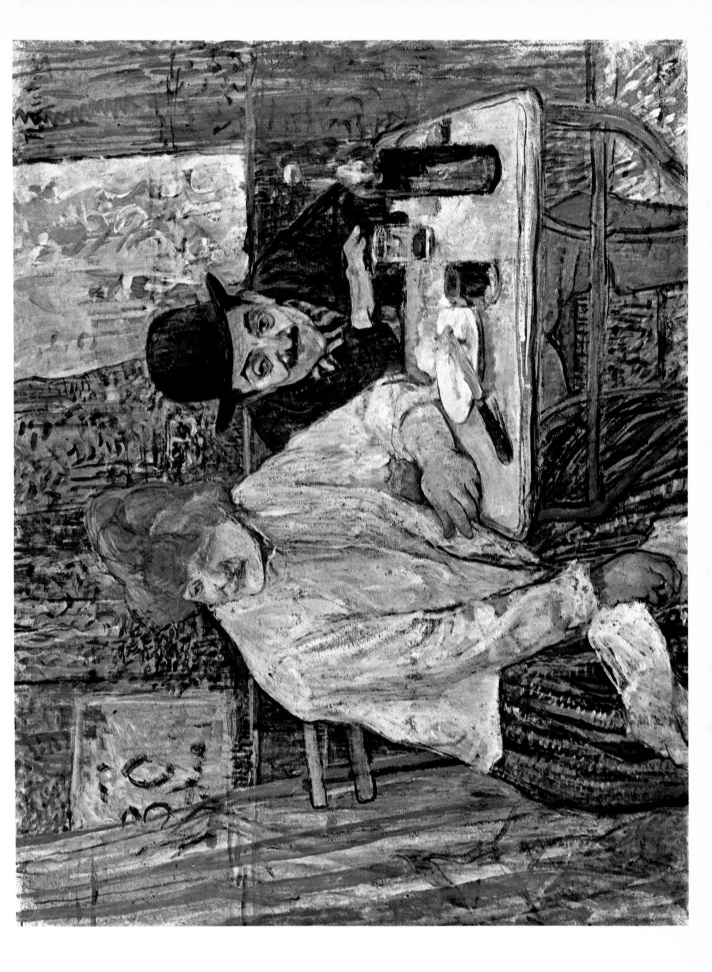

13. *Woman with Black Boa*

c.1892. Oil. $20\frac{7}{8} \times 16\frac{1}{8}$ in (53 × 41 cm)

One of the earlier portraits by Lautrec in which a dramatic and somewhat sinister effect is achieved through an element of caricature. This feature of his work culminates in the extravagant studies of Yvette Guilbert (*plates 24 and 25*). The picture's impact is in part due to the untreated background which gives prominence to the figure's contour – a device used by Lautrec on several occasions.

Paris, Louvre

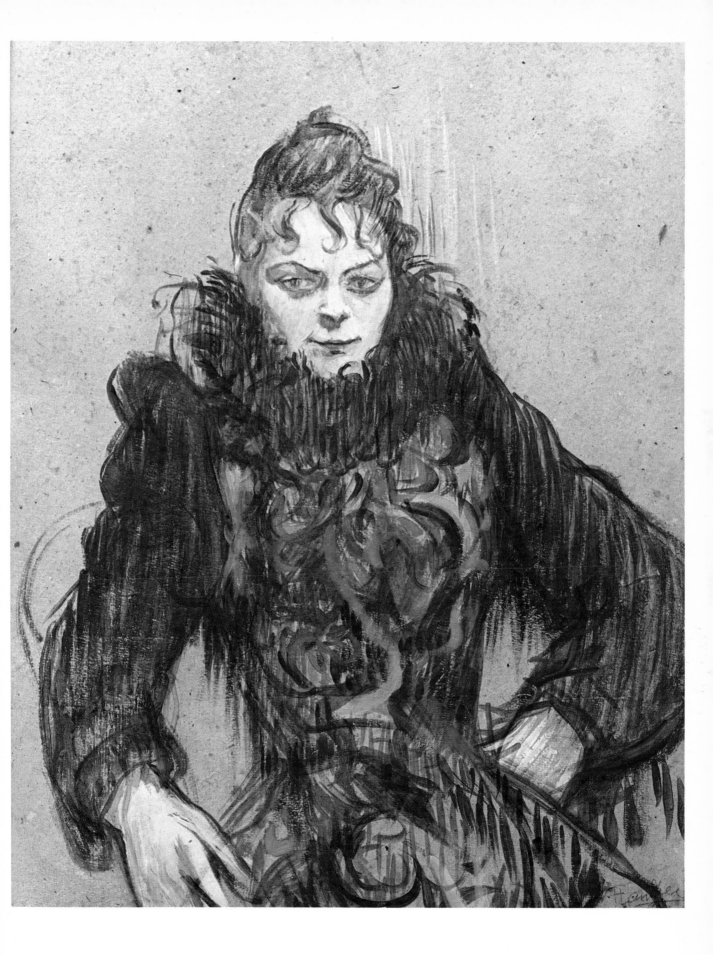

14. *Poster for the Moulin Rouge*

1891. Lithograph. $76\frac{3}{4} \times 48\frac{1}{8}$in (195 × 122cm)

Lautrec's most famous poster and the first in which his concise yet spacious sense of design, influenced by Japanese prints and Degas, flowered to create an image both personal and highly commercial. Partnering La Goulue is the sinister Valentin-le-Désossé ('boneless' or 'disjointed'), a nickname for Jacques Renaudin who by day was a café-proprietor.

Winterthur, Collection Oskar Reinhardt

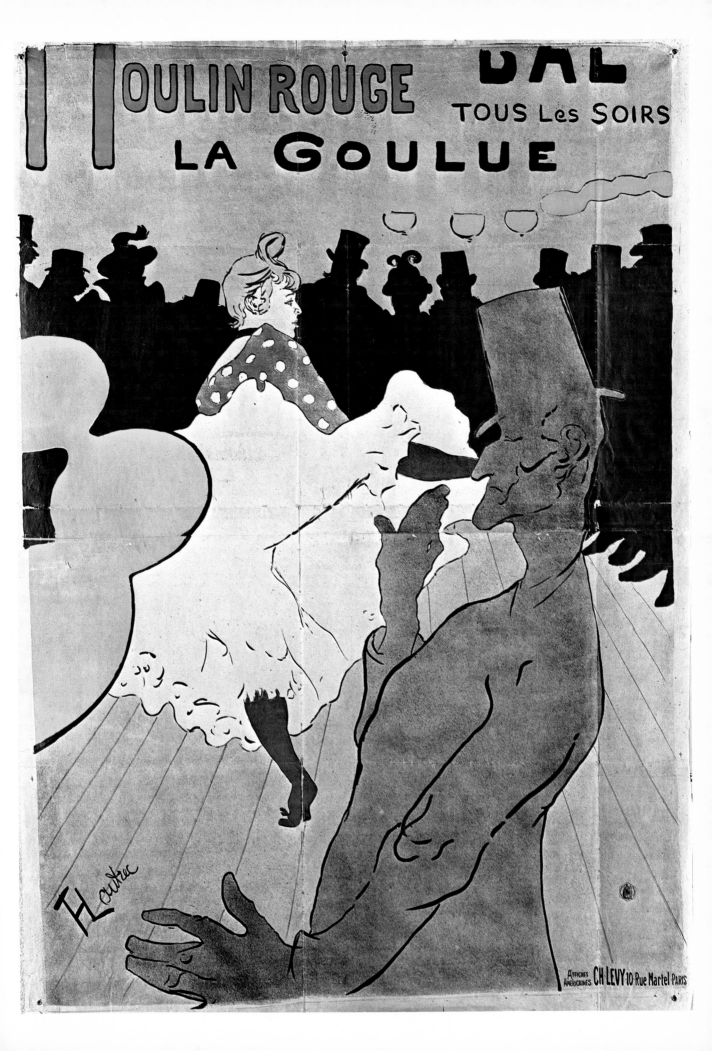

15. *La Goulue entering the Moulin Rouge*

1892. Oil. $31\frac{1}{2} \times 23\frac{5}{8}$in ($80 \times 60$cm)

Louise Weber (1870–1929) a laundry-girl, plump, vulgar and sharp-tongued, first appeared at the Cirque Médrano and after at the Moulin de la Galette. In 1889, the Moulin Rouge opened and under the name of La Goulue (the Glutton), she remained one of its chief stars until 1895, famous for her high-kicking execution of the quadrille. Here Lautrec, while showing her as insolent and brazen, gives her star-status as she enters grandly on the arms of two friends.

New York, Museum of Modern Art

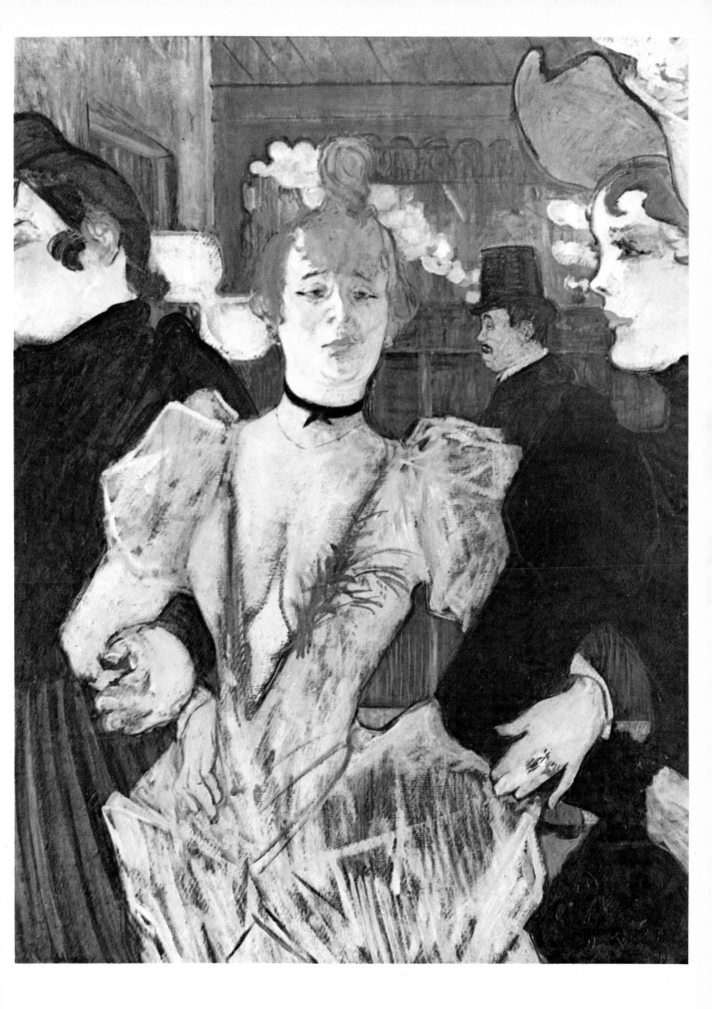

16. *Jane Avril dancing*

1892. Oil. $33\frac{5}{8} \times 17\frac{3}{4}$ in ($85 \cdot 5 \times 45$ cm)

Jane Avril was one of Lautrec's favourite dancers at the
Moulin Rouge and by his posters of her, he did much to
increase her reputation. She was more refined and
educated than La Goulue and the others; in the words of
Lautrec's friend, the painter William Rothenstein, she was
'a wild Botticelli-like creature, perverse but intelligent
whose madness for dancing induced her to join this
strange company'. Whereas La Goulue is usually depicted
with her partner or in a crowd of people, Jane Avril is
nearly always alone, self-absorbed and retaining a poise in
intricate movements which obviously delighted Lautrec.

Paris, Louvre

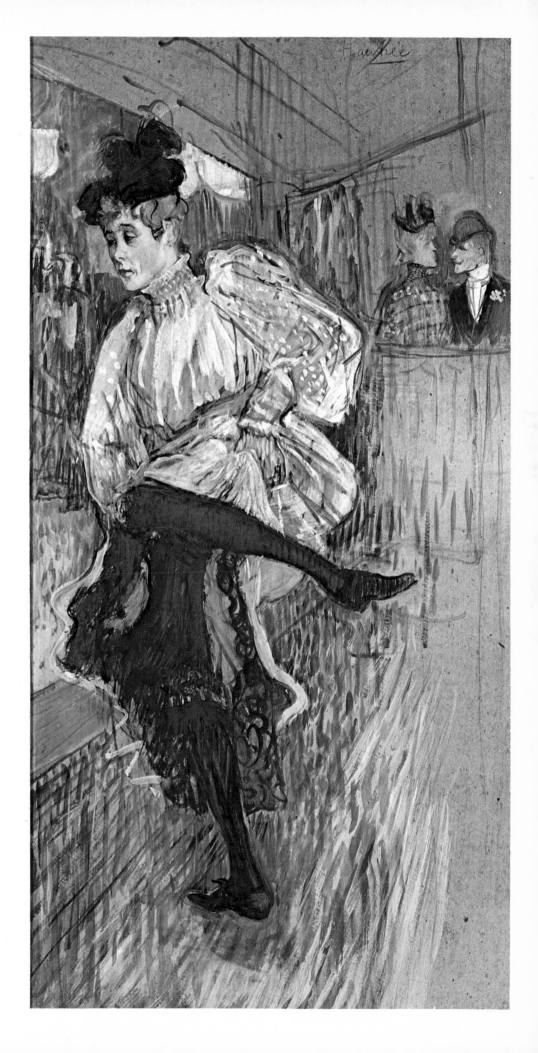

17. *Jane Avril at the entrance of the Moulin Rouge*

1892. Oil and pastel. $40 \times 21\frac{5}{8}$ in ($101 \cdot 5 \times 55$ cm)

The restrained and delicate off-stage character of Jane Avril is delineated here in one of Lautrec's most poignant portraits. The English writer Arthur Symons described her as 'altogether adorable and excitable, morbid and sombre, biting and stinging; a creature of cruel moods . . .' She was sometimes known as La Mélinite – the high explosive.

London, Courtauld Institute Galleries

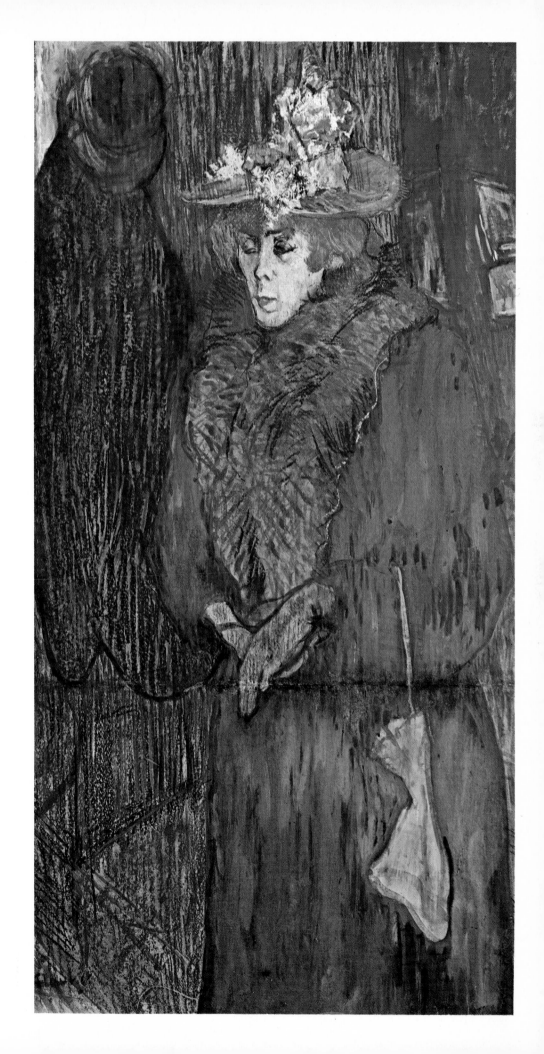

18. *Le Divan Japonais*

1892. Poster. 31¼ × 23½in (79·5 × 59·5cm)

Yvette Guilbert is singing on stage, identified by her
sinuous black gloves; looking on is Jane Avril, also a
performer at the 'Divan Japonais' cabaret. She is
accompanied by Edouard Dujardin, critic and man-about-
town who also appears in *At the Moulin Rouge* (1892,
Chicago Art Institute). The curling, expressive details of
the black hat, the conductor's arms, the instruments and
the yellow glove add a touch of Art Nouveau decoration to
this resonant image.

London, Victoria and Albert Museum

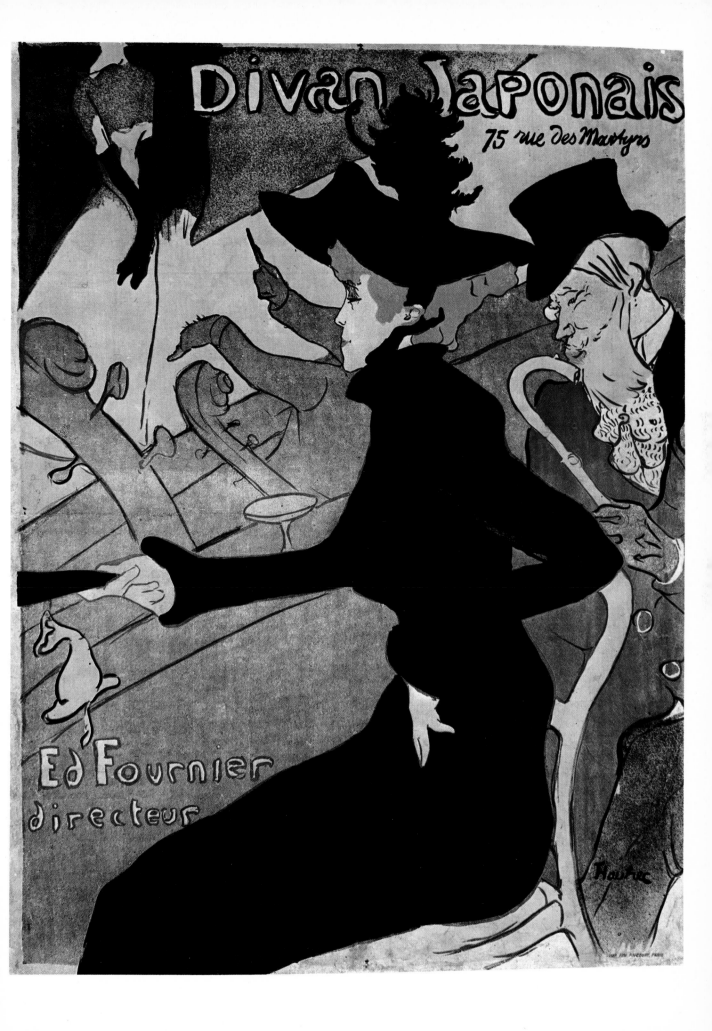

19. *Ambassadeurs: Aristide Bruant*

1892. Lithograph. 51 × 39⅜in (150 × 100cm)

Lautrec's first lithograph (1885) was the cover design for a song by Aristide Bruant, the singer and cabaret manager; it was at his café chantant Le Mirliton, that Lautrec had his first exhibition. The robust, burly, sometimes violent Bruant sang songs of Parisian low-life; he commissioned other posters from Lautrec for his appearance at Le Mirliton and the Eldorado.

London, Victoria and Albert Museum

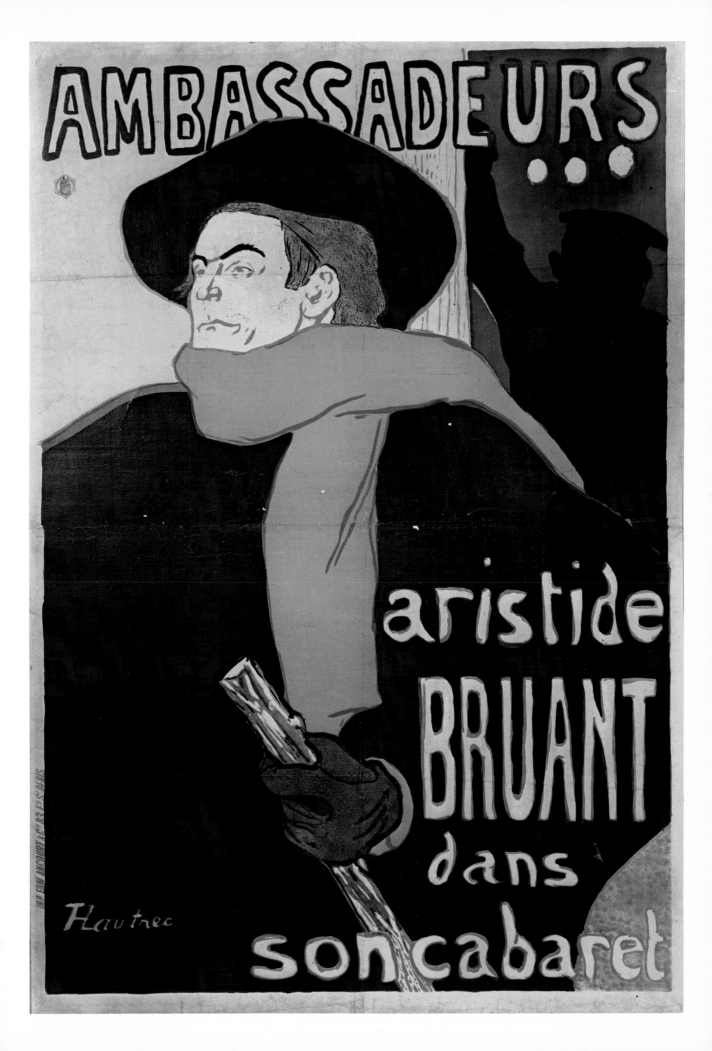

20. *The Englishman at the Moulin Rouge*

c.1893. Lithograph. $18\frac{1}{2} \times 14\frac{5}{8}$ in (47 × 37·2cm)

Lautrec's inventive and often arbitrary colour, his sweeping contours and fine placing of details are seen together here in one of his most exciting lithographs.

The Englishman was Lautrec's painter friend, T.A. Warrener. The two girls Rayon d'Or and La Sauterelle ('The Grasshopper') were also familiar figures at the Moulin Rouge. The oil painting on which this lithograph is based is in the Metropolitan Museum of Art, New York.

Albi, Musée Toulouse-Lautrec

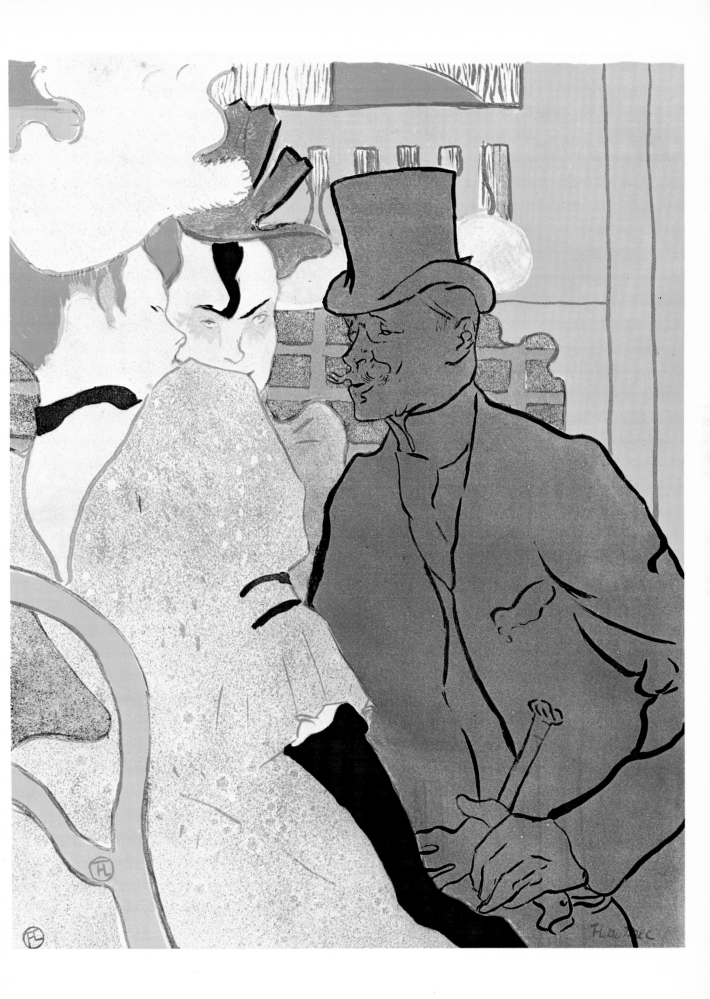

21. *In Bed*

c.1893. Oil. 21$\frac{1}{4}$ × 27$\frac{3}{4}$in (54 × 70·5cm)

In 1892 Lautrec was asked to provide decorations for the salon of a brothel he frequented in the rue d'Amboise. While working there he came to know several of the prostitutes, making many drawings and paintings of them. The two girls shown here were lovers and Lautrec became fascinated by the lesbian attachments within the brothels he visited. They appear again in *The Kiss* (Private Collection, France).

Paris, Louvre

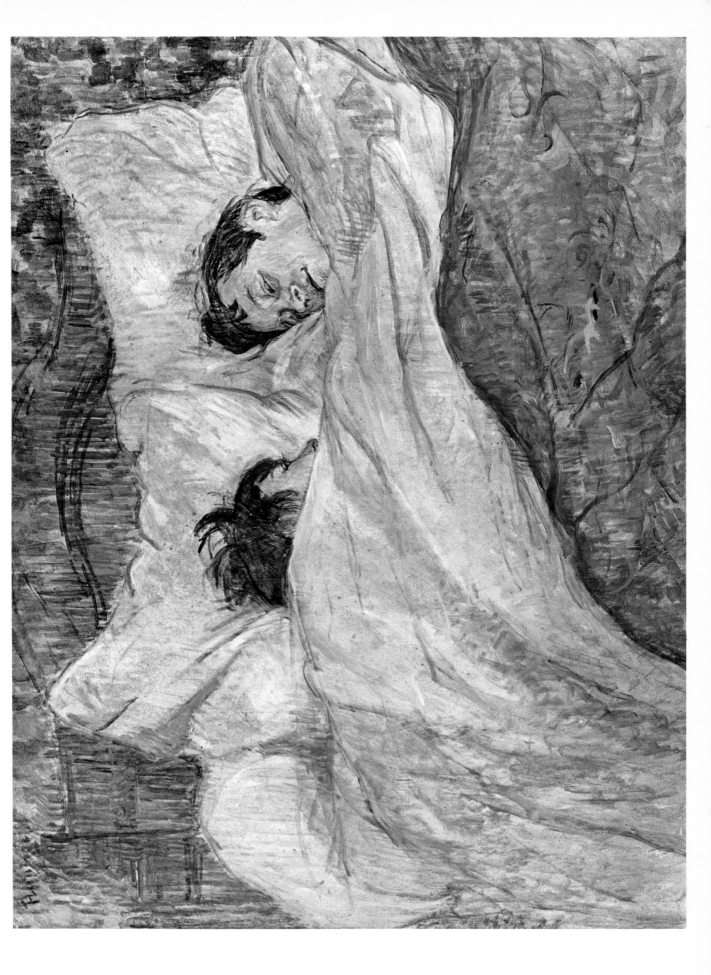

22. *Rue des Moulins (The Medical Inspection)*

1894. Oil. 32⅞ × 71 in (83·5 × 180·4cm)

This picture shows two prostitutes awaiting their monthly inspection for venereal disease. The subtle ironies of Lautrec's characterization and his impartial treatment of a potentially gross subject make this one of the finest of these studies he made while living for several months in the well-appointed brothel in the rue des Moulins.

Washington, National Gallery of Art

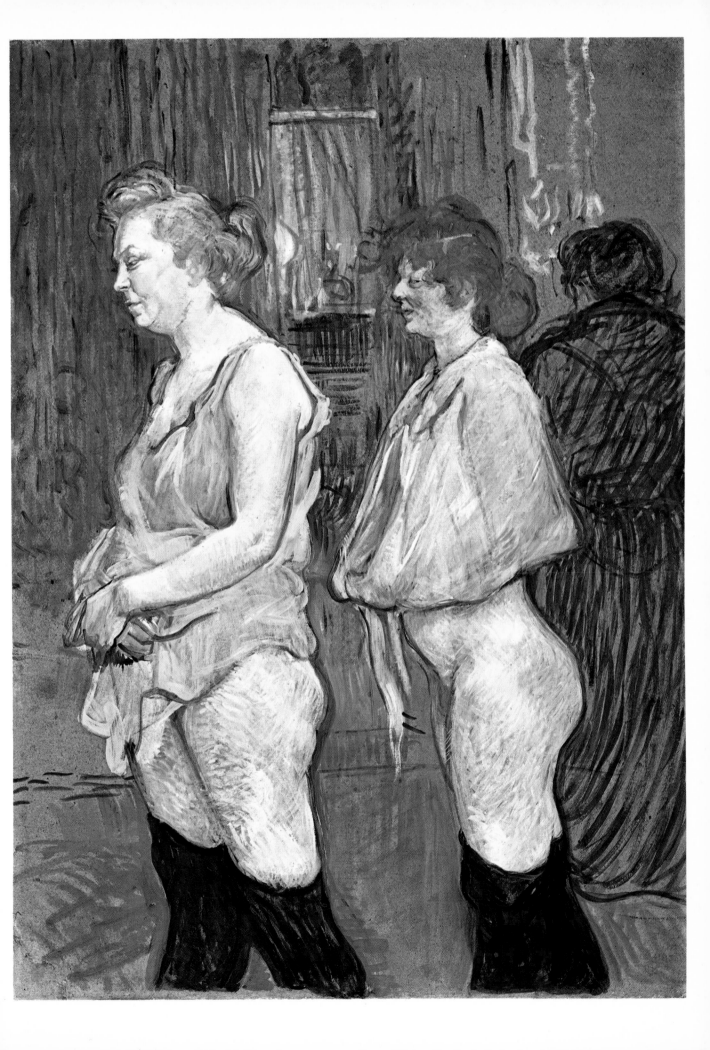

23. *The Salon in the rue des Moulins*

1894–95. Oil. 43⅞ × 51⅛in (111·5 × 132·5cm)

One of Lautrec's masterpieces, this elaborate view of the
ornate salon of the rue des Moulins brothel was painted in
his studio from drawings made on the spot. All Lautrec's
compositional resources are brought into play here,
revolving around the strong diagonal of the girl's extended
leg and arm as she waits for a customer under the
watchful eyes of the decorous *madame*.

Albi, Musée Toulouse-Lautrec

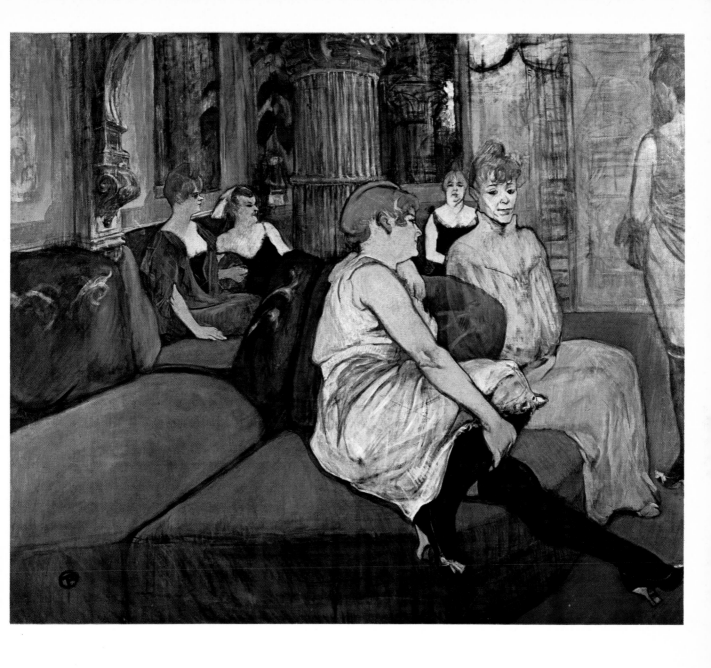

24. *Yvette Guilbert taking a Curtain Call*

1894. Oil. $18\frac{7}{8} \times 11$in (48×28cm)

Of all the stars portrayed by Lautrec, the singer Yvette Guilbert (1868–1944) attracted him perhaps most of all and she was frequently portrayed by him in sketches, lithographs and posters. Her distinctive appearance – so simple in contrast to many fellow performers – inspired Lautrec to make some of his most haunting and audacious images. This swiftly worked study was painted by Lautrec on top of an enlargement of an original lithograph of the singer. In the following year Lautrec published an album of sixteen prints of Yvette Guilbert which were initially regarded by her as wicked travesties of her appearance.

Albi, Musée Toulouse-Lautrec

25. *Yvette Guilbert*

1894. Oil. 73¾ × 36⅝in (186 × 93cm)

Another study of Yvette Guilbert on stage in her familiar green dress and black gloves, Lautrec has brilliantly captured her expression following perhaps some outrageous *double entendre* in a seemingly innocent song. Unlike many of the performers depicted by Lautrec, Guilbert was a star of international repute, giving concerts until a few years before her death. Her earlier *risqué* repertoire was later changed to a more decorous rendering of ballads and folksongs.

Albi, Musée Toulouse-Lautrec

26. *May Belfort*

1895. Poster. 31 × 23⅝in (78·8 × 60cm)

Lautrec painted May Belfort and designed posters for her several times in 1895, the year the young Irish singer was appearing at Les Décadents. Lautrec was superbly sensitive as to the amount and kind of lettering on his posters. The homely, even child-like letters in this suit the singer as much as the strong outlines of *Ambassadeurs (plate 19)* suit the personality of Aristide Bruant.

London, Victoria and Albert Museum

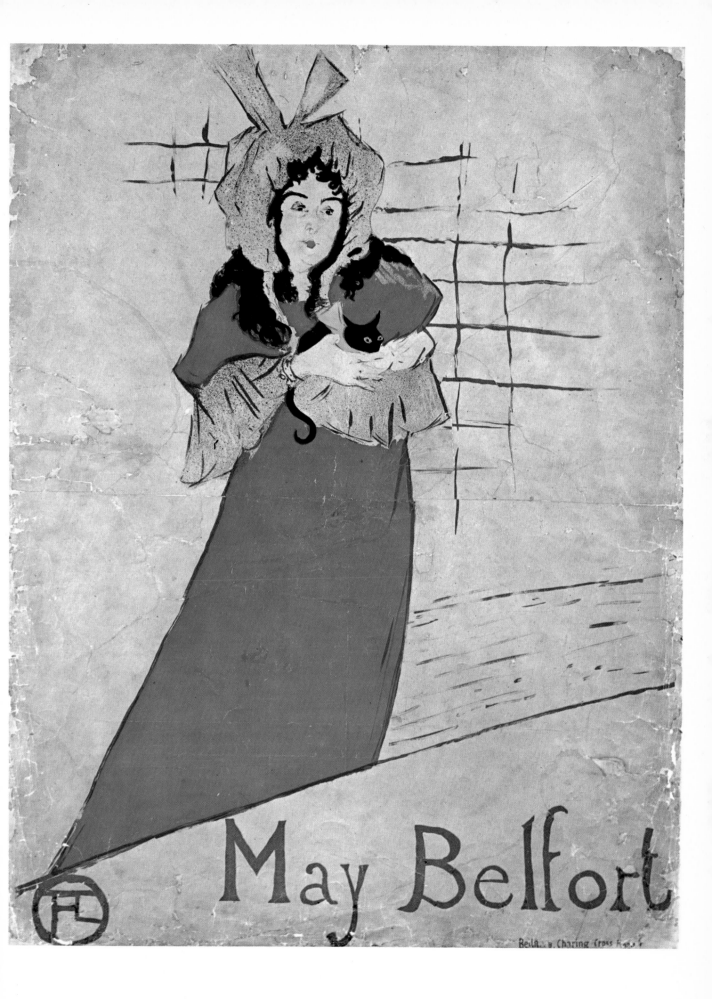

May Belfort

Beila.. v. Charing Cross Road

27. *Marcelle Lender dancing the Bolero in 'Chilpéric'*

1895. Oil. 57½ × 57⅞in (120·5 × 121·5cm)

Chilpéric, an opéra-bouffe by Hervé, was revived at the Théâtre des Variétés in February 1895 with Marcelle Lender as Queen Galswintha, seen here dancing before King Chilpéric on his throne. This large, decorative canvas, the fruit of many studies, was Lautrec's last sustained composition, a synthesis of much that had gone before, particularly of Lautrec's ability to relate a complex group of figures without denying individuality to any one of them.

New York, Collection Mr and Mrs John Hay Whitney

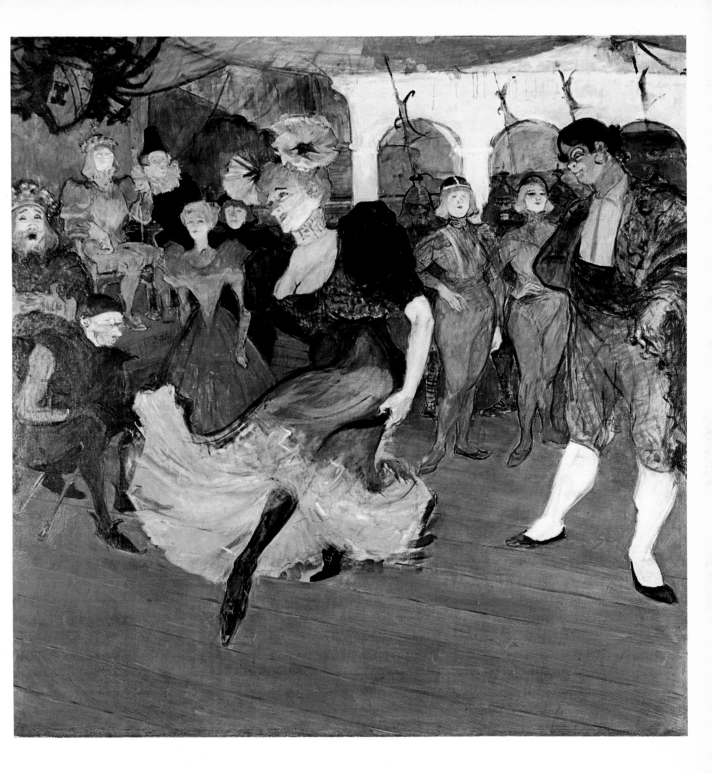

28. Mlle Marcelle Lender

1895. Lithograph. 12 × 8¾in (30·5 × 22·2cm)

A lithograph of the young actress Marcelle Lender as she appeared in *Chilpéric* (see *plate 27*). Lautrec's appreciations were by no means confined to the singers and dancers of popular halls and cabarets; the great actors and actresses (such as Sarah Bernhardt) form the subject of many drawings and lithographs. Lautrec was a tireless experimenter with various colour schemes and textures for his lithographs; several versions of this one are known before it reached its final state as seen here.

London, Victoria and Albert Museum

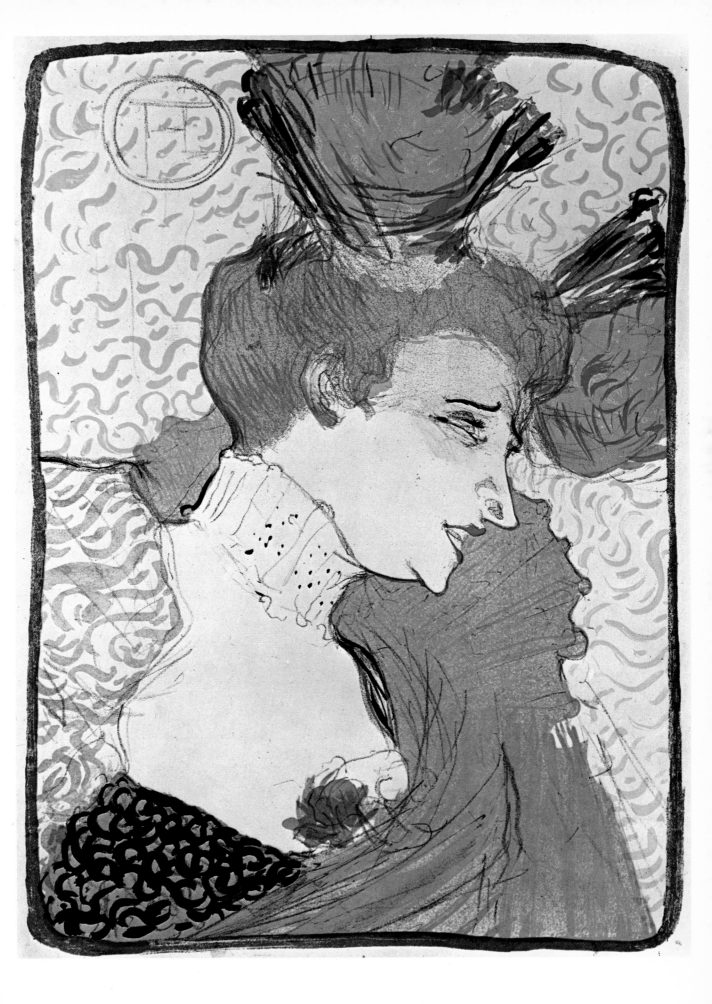

29. *Panel for La Goulue's Booth, Foire du Trône*

1895. Oil. 117⅜ × 124⅜in (298 × 396cm)

This and plate 30 originally formed the two sides to the
entrance of La Goulue's booth in an open-air fairground in
Montmartre and were painted at the dancer's request. In
this one, the painter has shown La Goulue at the height of
her fame dancing with Valentin-le-Désossé at the Moulin
Rouge. The opening of her booth was not a great success;
alcohol and obesity were already beginning to diminish
her attractions.

Paris, Louvre

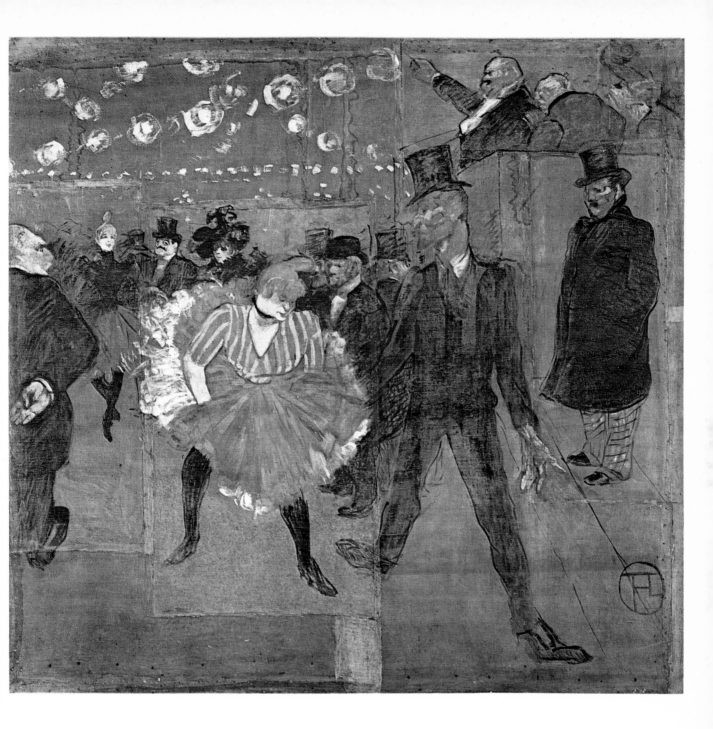

30. *Panel for La Goulue's Booth, Foire du Trône*

1895. Oil. 112$\frac{1}{2}$ × 121$\frac{1}{4}$in (285 × 307·5cm)

Having shown La Goulue at the height of her fame in one panel (*plate 29*) Lautrec depicted the present in the other. She is seen in a semi-oriental dance in the midst of the harem. Looking on are (left to right, foreground) Lautrec's cousin Tapié de Céleyran, Oscar Wilde, Jane Avril, Lautrec himself and the critic, Fénéon. La Goulue's comeback, which Lautrec celebrates here, was brief; after various jobs which included animal taming and street-selling, drink and poverty took their toll and she died destitute in 1929.

Paris, Louvre

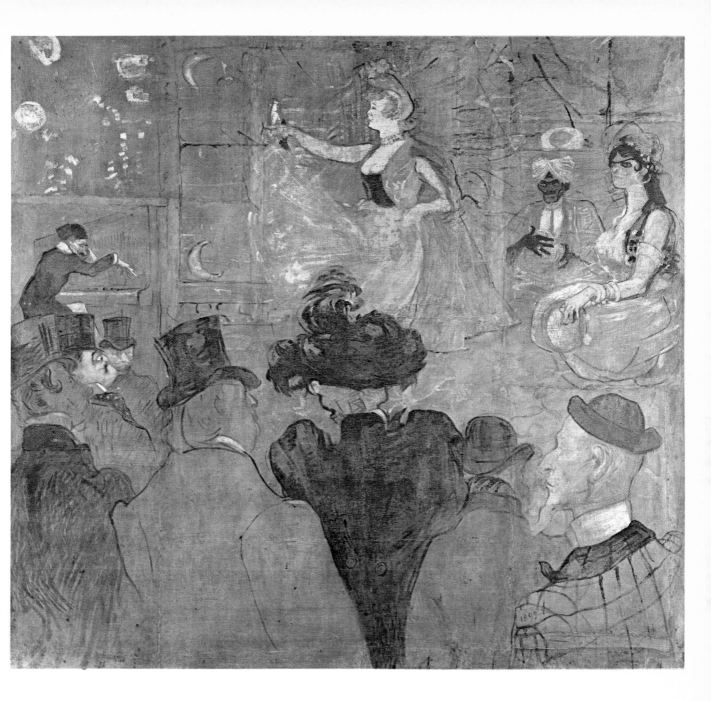

31. *Cha-U-Kao, The Female Clown*

1895. Oil. 25¼ × 18¼in (64 × 49cm)

This is one of several paintings and drawings of Cha-U-Kao, a robust female clown who appeared at the Moulin Rouge and elsewhere. Here she is shown in her dressing room, or perhaps a private dining room in a restaurant, about to have supper with the elderly man reflected in the mirror.

Paris, Louvre

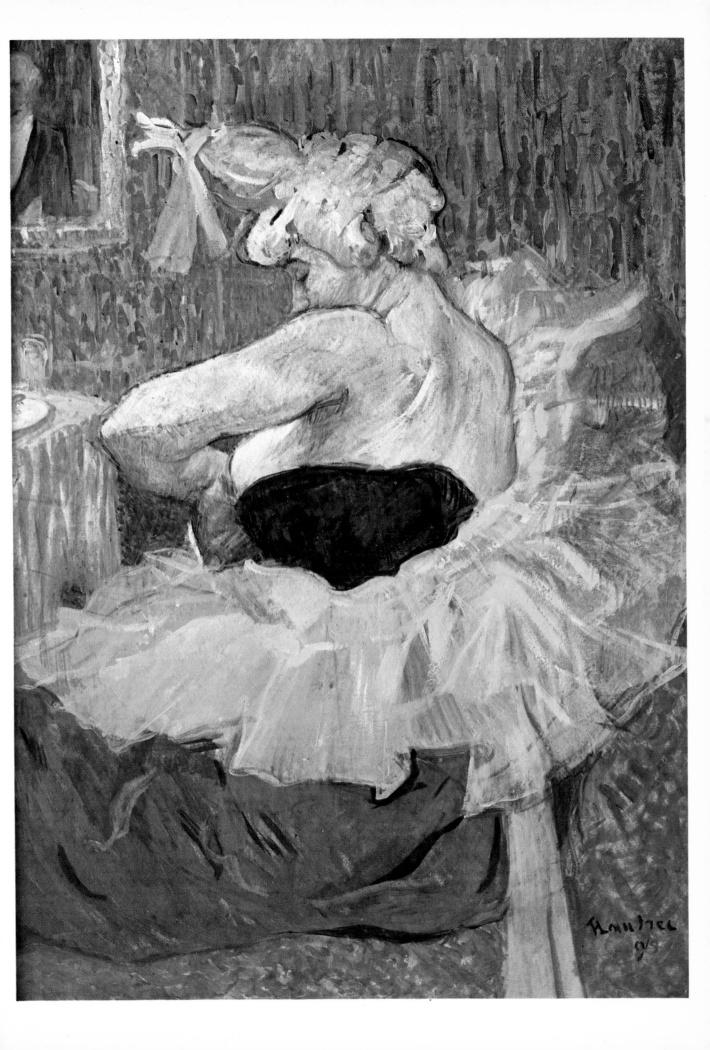

32. *Cha-U-Kao at the Moulin Rouge*

1895. Oil. 29½ × 21⅝in (75 × 55cm)

The powerfully composed, private image of Cha-U-Kao in the previous plate contrasts here with her public appearance as she passes through the crowds at the Moulin Rouge on the arm of Gabrielle la Danseuse. The writer Tristan Bernard is seen behind her left shoulder. This arresting painting was one of the last in which Lautrec was inspired by the Moulin Rouge.

Winterthur, Collection Oskar Reinhardt

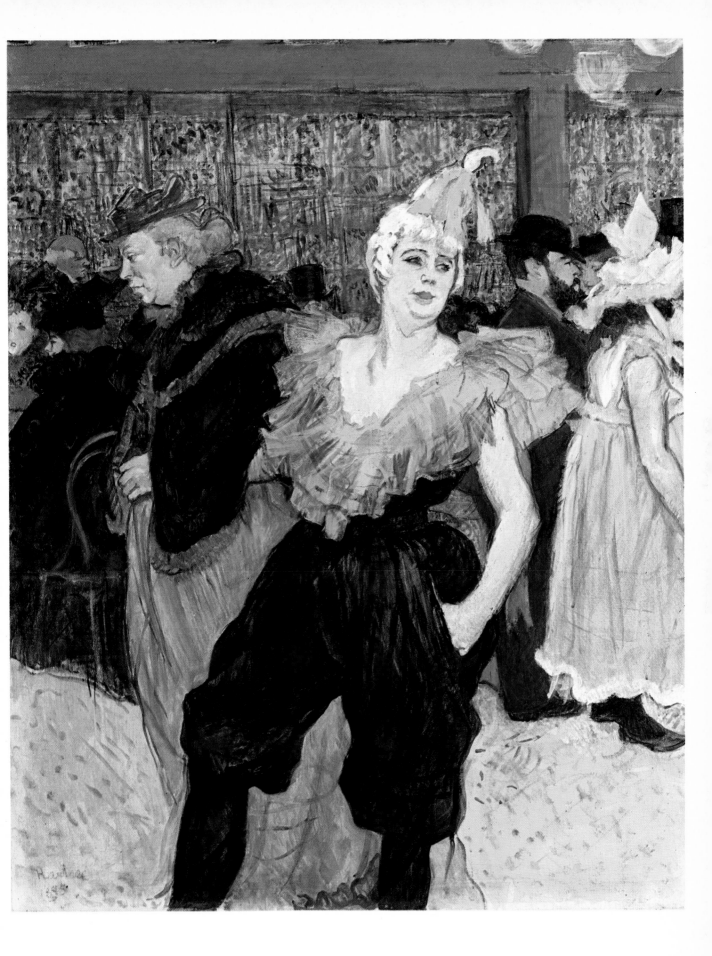

33. *Napoleon Riding*

1895. Lithograph. 20¼ × 14¼ in (51·5 × 36cm)

This unusual lithograph, showing Napoleon followed by a General and a Mameluke, was the result of an abortive entry by Lautrec for a competition. It was originally conceived as a poster to advertise the American publication of Professor Sloane's life of Napoleon. Lautrec's entry was rejected by the judges and the design was later made into a lithograph.

Albi, Musée Toulouse-Lautrec

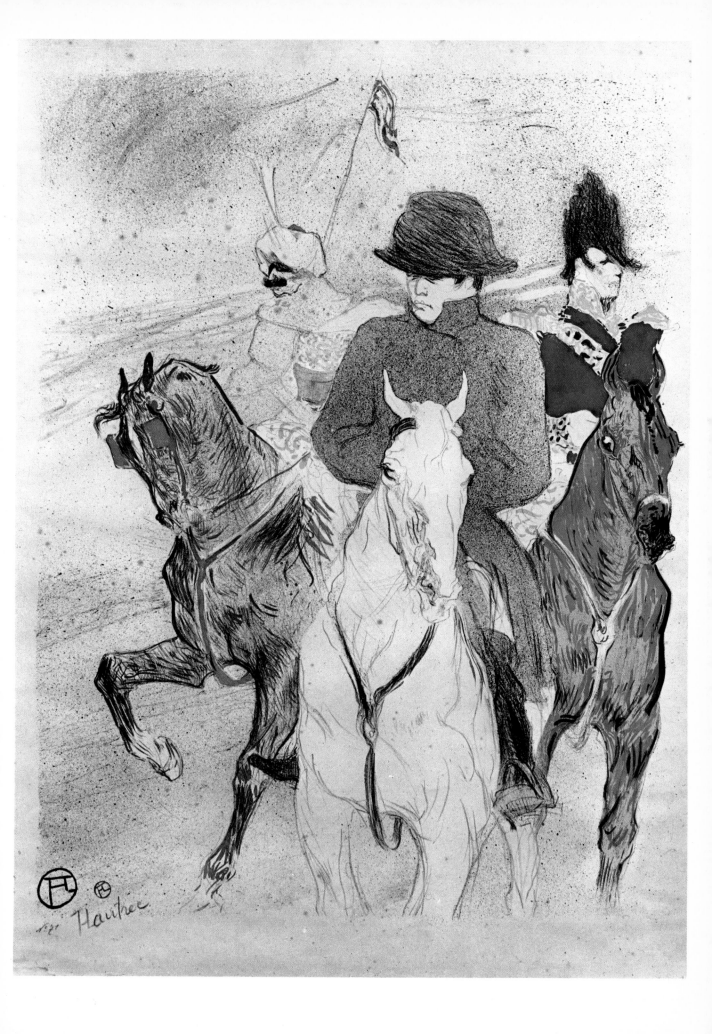

34. *Portrait of Paul Leclercq*

1897. Oil. $21\frac{1}{4} \times 26\frac{3}{4}$in ($54 \times 67$cm)

Leclercq, a friend and admirer of Lautrec, was a writer and founder-editor of *La Revue Blanche* (see introduction, page 4). Leclercq left a description of his sitting for this portrait; 'While he was painting he remained silent and, licking his lips, seemed to be relishing something with an exquisite taste.'

Paris, Louvre

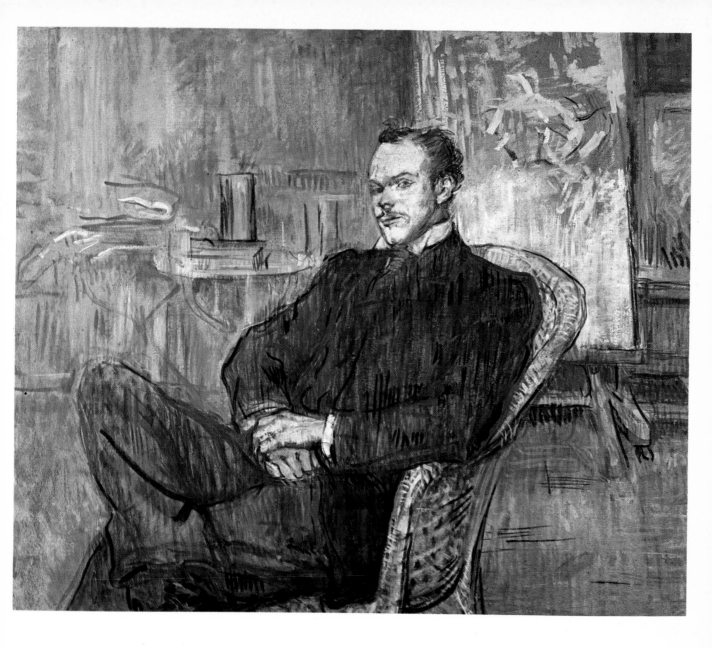

35. *In the Bar: The Fat Proprietor and the Anaemic Cashier*

1898. Oil. 32⅛ × 23⅝in (81·5 × 60cm)

This uninhibited caricature – such studies in contrast delighted Lautrec – is one of the last pictures of Lautrec's great period. The foreground still life already *shows some signs of weakness in placing*, although the proprietor's head is carried out with splendid economy and brio.

Zurich, Kunsthaus

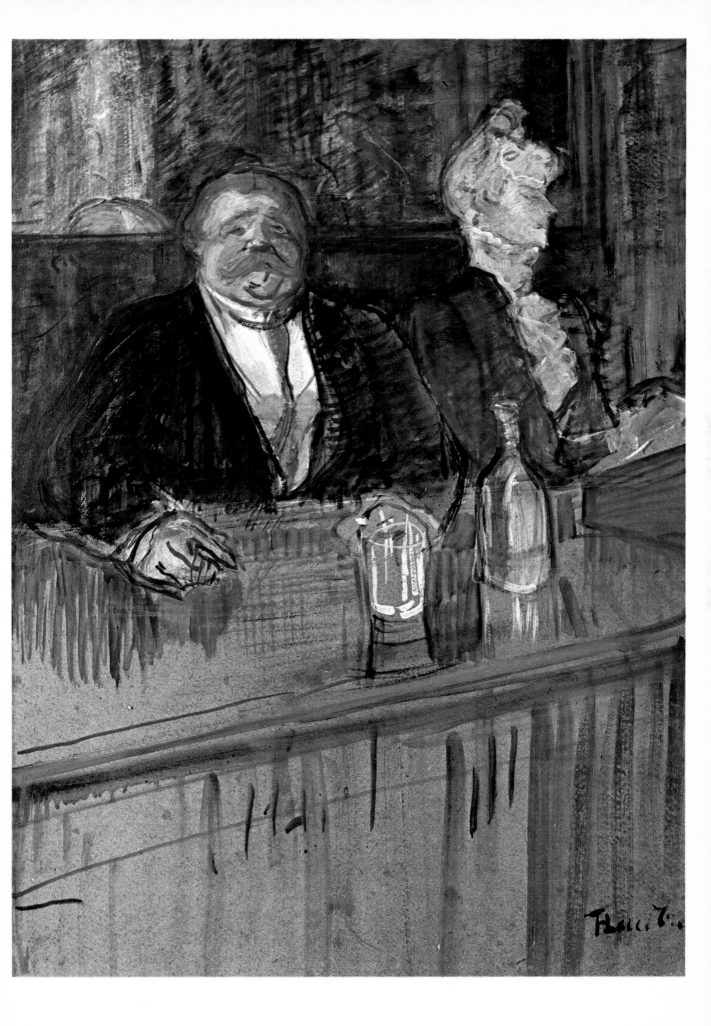

36. Au 'Rat Mort'

1899. Oil. 21⅝ × 18⅛in (55 × 46cm)

The Rat Mort was a fashionable and expensive restaurant in the rue Pigalle noted for its private dining rooms. This study is one of the few successful paintings of Lautrec's last years, painted in Paris after a summer spent convalescing following his release from a sanatorium at Neuilly where he had gone after a complete physical and mental breakdown. It shows a new painterliness and the concern for tonal colour which occupied Lautrec in the two years before his death.

London, Courtauld Institute Galleries

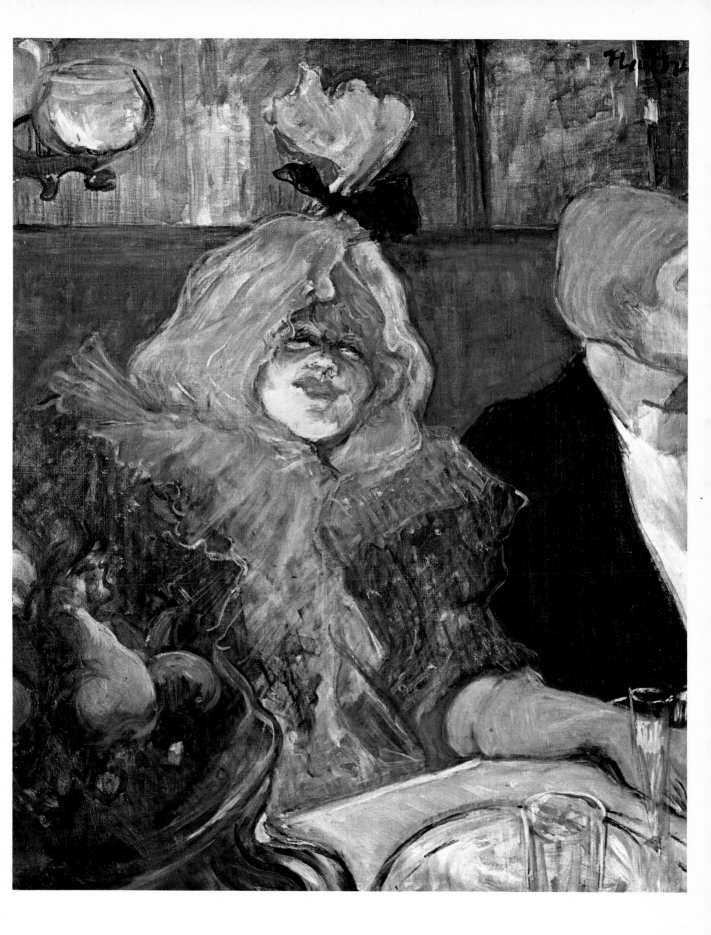

37. English Girl at the 'Star', Le Havre

1899. Oil. $16\frac{1}{8} \times 12\frac{5}{8}$in (41 × 32cm)

Miss Dolly was a waitress in an English bar at Le Havre where Lautrec stayed before embarking for Bordeaux after his release from Neuilly. It is the most obviously brilliant of his last works, if less penetrating as a character study than usual. A profile drawing of the same girl is also at Albi.

Albi, Musée Toulouse-Lautrec

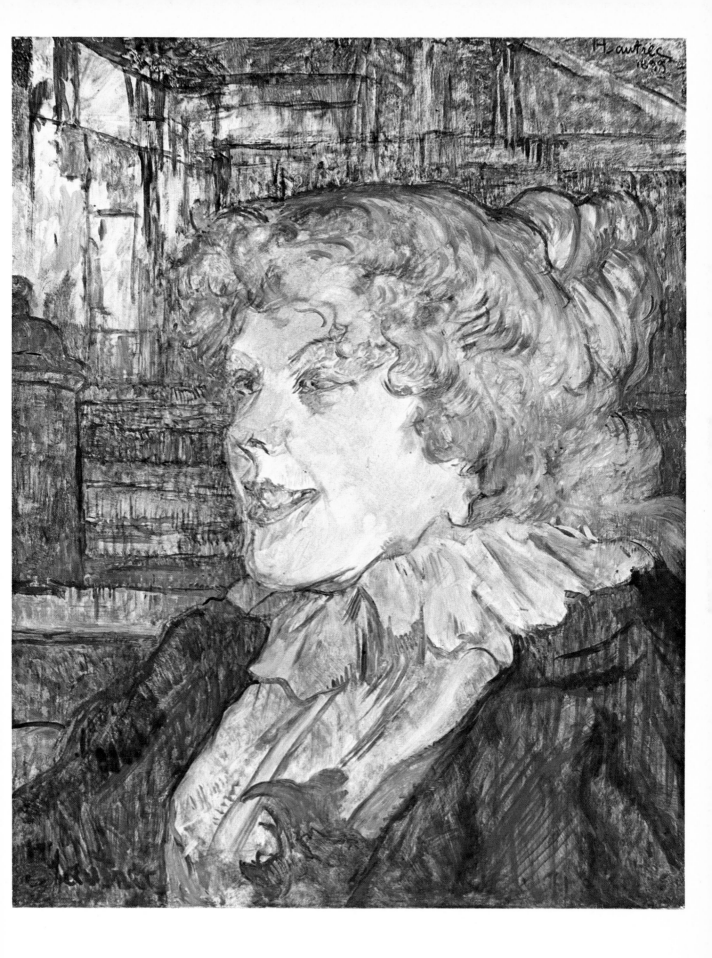

38. *Mme Poupoule at her Dressing Table*

1900. Oil. 24 × 19½in (60·8 × 49·6cm)

Another of Lautrec's last paintings, the uncertain handling of which reflects Lautrec's deteriorating health and powers of concentration. The tranquil mood, suggested by the subdued colours and fine drawings of the girl's features, in some way compensates for the loose structural organization of the whole.

Albi, Musée Toulouse-Lautrec

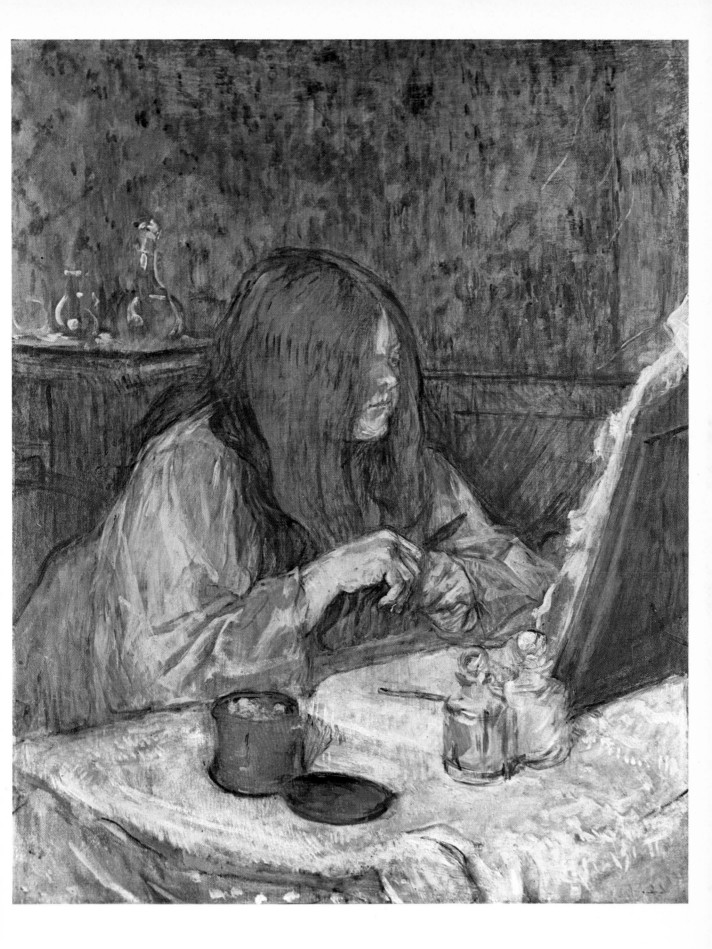

39. *The Jockey*

1899. Lithograph. 20¼ × 14¼in (51·5 × 36cm)

Lautrec was familiar with the world of horse-racing and hunting from his birth and like so many other energetic pursuits such as dancing and horse-riding , it obsessed him – from his earliest efforts as a boy to the last haunting series of Circus drawings done from memory at Neuilly. Originally conceived as part of a series of racing subjects, the commission was never completed.

London, Victoria and Albert Museum

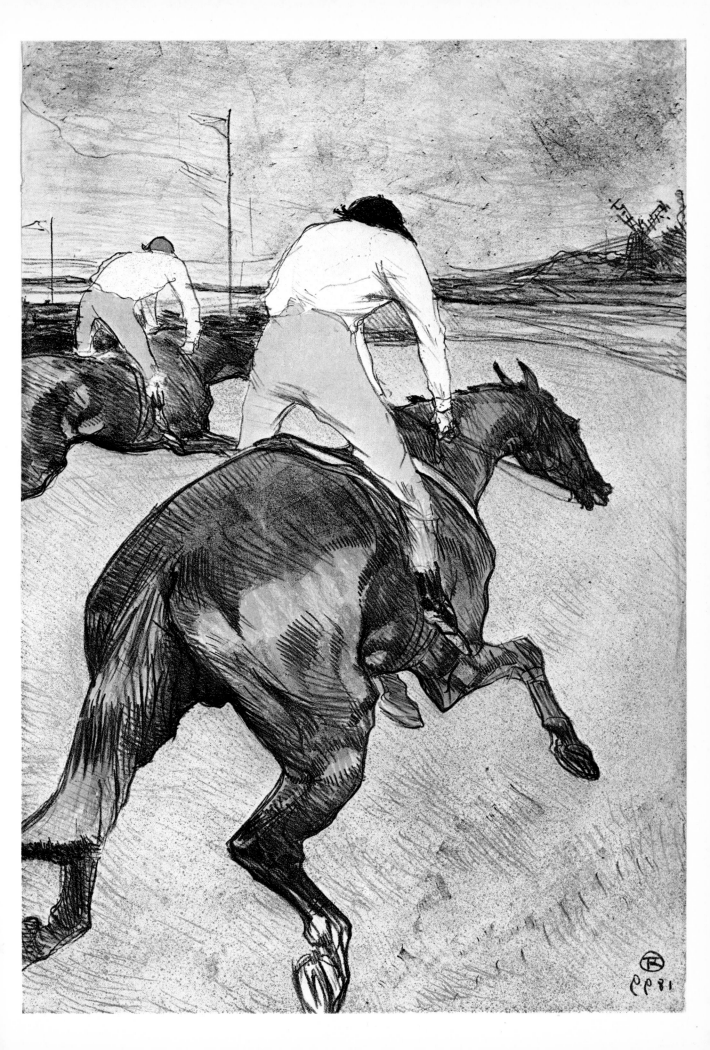

40. *An Examination at the Faculty of Medicine, Paris*

1901. Oil. 25⅝ × 31⅞in (65 × 81cm)

This study of Tapié de Céleyran under examination for his doctoral thesis was the artist's last picture, on which he worked for several months in the summer before his death. The strong modelling, dramatic lighting and shades of Daumier and Rouault strike a new note in Lautrec's work, fumblingly executed though it be in comparison with paintings of his best period.

Albi, Musée Toulouse-Lautrec

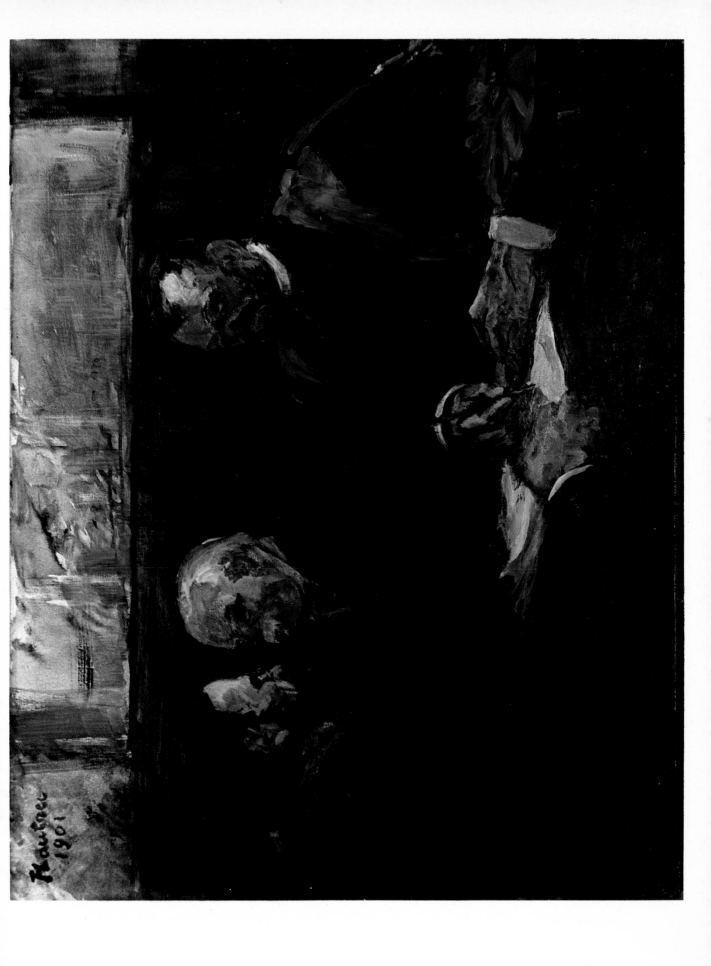

RICHARD SHONE AND BLACKER CALMANN COOPER LIMITED *would like to thank the museums and owners for allowing works from their collections to be reproduced, in particular Musée Toulouse-Lautrec, Albi, and the Louvre, Paris. Reproduced by courtesy of the Art Institute, Chicago, are Plate 6 (The Joseph Winterbotham Collection, 1925) and Plate 7 (Mr & Mrs Lewis L. Coburn Memorial Collection, 1933). Plate 10 is reproduced by permission of the Barber Institute of Fine Arts, University of Birmingham; Plate 12 by courtesy of the Museum of Fine Arts, Boston (S.A. Denio Fund and General Income for 1940); Plate 15 by permission of the Collection, The Museum of Modern Art, New York (Gift of Mrs David M. Levy); Plate 22 by permission of the National Gallery of Art, Washington (Chester Dale Collection); and Plates 14 and 32 by permission of the Collection Oskar Reinhardt 'Am Römerholz'. Transparencies were provided by Cliché Musées Nationaux, Paris (Plates 8, 9, 13, 16, 21 and 29–32), the Cooper-Bridgeman Library, London (Plate 14), Lauros-Giraudon (Plates 20 and 33) and John Webb (Plate 4).*